Kawaii Doodle Cuties

SKETCHING SUPER-CUTE STUFF FROM AROUND THE WORLD

Zainab Khan

CREATOR OF

Pic Candle

Race Point
PUBLISHING

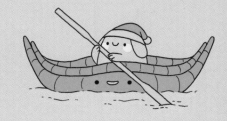

Inspiring | Educating | Creating | Entertaining

Brimming with creative inspiration, how-to projects, and useful information to enrich your everyday life, Quarto Knows is a favorite destination for those pursuing their interests and passions. Visit our site and dig deeper with our books into your area of interest: Quarto Creates, Quarto Cooks, Quarto Homes, Quarto Lives, Quarto Drives, Quarto Explores, Quarto Gifts, or Quarto Kids.

First published in 2018 by Race Point Publishing, an imprint of The Quarto Group, 142 West 36th Street, 4th Floor, New York, NY 10018, USA
T (212) 779-4972 F (212) 779-6058 **www.QuartoKnows.com**

Race Point Publishing titles are also available at discount for retail, wholesale, promotional, and bulk purchase. For details, contact the Special Sales Manager by email at specialsales@quarto.com or by mail at The Quarto Group, Attn: Special Sales Manager, 401 Second Avenue North, Suite 310, Minneapolis, MN 55401, USA.

10 9 8 7 6 5 4 3 2

ISBN: 978-1-63106-568-2

Editorial Director: Jeannine Dillon
Creative Director: Regina Grenier
Managing and Project Editor: Erin Canning
Art Director: Anne Re
Cover Design: Zainab Khan

Printed in China

MIX
Paper from
responsible sources
FSC® C016973

Contents

Adorable Food 13

Precious Nature & Natural Wonders 33

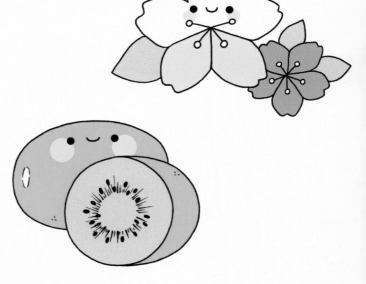

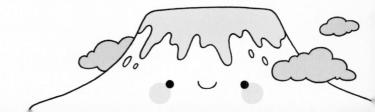

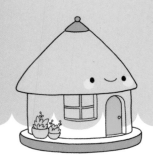

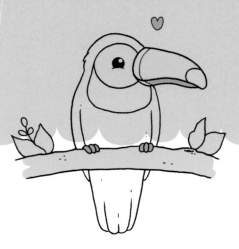

Enchanting Architecture & Monuments — 49

Lovable Animals & Birds — 71

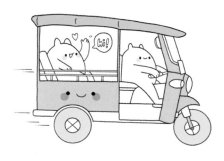

Charming Transportation — 85

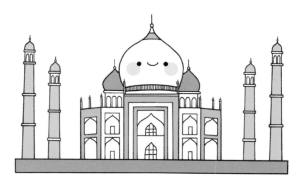

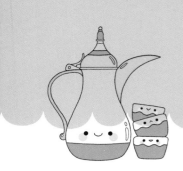

Fetching Fashion 101

Fun Time! 129

Everyday Cute 115

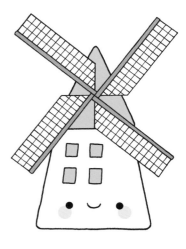

Hi!

My name is Zainab, but you can find my kawaii doodles on the internet under the handle Pic Candle. I recently quit my day job to doodle full time, because I love drawing so much. Crazy, right?!

I approach my doodles randomly without planning or thinking about the end results. I find this process to be very exciting because you never know what's going to happen.

It's a surprise! I usually start with a doodle character or object that comes to mind and then keep drawing more characters and decorations, one by one, to fill up the page (see my Search-&-Find Puzzles starting on page 129). While doodling, I focus only on the character or object that I'm drawing, not the big picture.

Regarding coming up with characters, they're mainly inspired by real-life objects and simple shapes (such as a sphere, cube, cylinder, pyramid, and cone) that I have modified or combined. I also like creating make-believe characters (see my doodle monsters throughout this book).

I hope this book inspires you to develop a love for doodling and creating kawaii characters. So grab your passport, because the *Kawaii Doodle Cuties* grand tour is about to begin!

What Is Kawaii?

You might have heard the word. You have probably seen the hashtag. You definitely know the style. But what, exactly, does *kawaii* mean?

Kawaii is a Japanese concept or idea, dating back to the 1970s, that translates closely to "cuteness" in English. In Japan, the usage of the word is quite broad and can be used to describe *anything* cute, from clothing and accessories to handwriting and art. So if you are a fan of emoji art or the style of beloved characters like Hello Kitty, Pokémon, or Pusheen the Cat, then you already know and love the kawaii style of art!

While there are many interpretations as to what constitutes the "kawaii" art aesthetic, most people can agree that kawaii art is usually composed of very simple black outlines, pastel colors, and characters or objects with a rounded, youthful appearance. Facial expressions in kawaii art are minimal and characters are frequently drawn with oversized heads and smaller bodies.

In this book, I'll show you how to draw kawaii-inspired art using things from around the world, like food, nature, architecture, and more. The great thing about kawaii culture is that it's not limited to anything, so once you start practicing, you can turn even the most common thing into something kawaii!

How to Use This Book

Kawaii Doodle Cuties includes seven sections (Adorable Food, Precious Nature & Natural Wonders, Enchanting Architecture & Monuments, Lovable Animals & Birds, Charming Transportation, Fetching Fashion, and Everyday Cute) with more than 65 characters for you to learn how to draw.

Each character is illustrated with simple step-by-step instructions to get you started doodling. Each chapter also includes Get Inspired pages, showing you even more doodle ideas.

At the back of the book is a section called Fun Time! with Search-&-Find Puzzles that you can also color.

Tools

You don't need to invest in many tools to get started doodling kawaii. You can use pen and paper, or you can draw digitally, or you can start with pen and paper and then scan your art in case you want to color it digitally. It's up to you!

BLACK PENS
The pens I use most are fineliner pens as they come in various tip sizes. I prefer to work with 3 tip sizes for varying line widths, though your end results can also be achieved using only one pen. Here are the tip sizes I use:

- thin tip (for tiny details, patterns, and shadows)

- medium-size tip (for main outlining)

- thick tip (for thicker outlining outside of the main outlines—this is to make characters stand out and also for filling in large areas with black)

WHITE PENS
I use these for corrections and adding highlights.

PAPER
I'm not too picky when it comes to the paper I use for doodling. Basic sketchbooks and printer paper work just fine, but if you want to use something more professional, that's a personal preference.

MECHANICAL PENCILS
Since ink is permanent, sketching with pencil before inking is helpful when drawing complex characters. Mechanical pencils are great for drawing lines and the option of varying lead thicknesses is useful.

ERASER

A good eraser is always needed for fixing those sketching mistakes. And there are always mistakes!

RULER

Depending on how precise you want to be with your lines and such, it can't hurt to have a ruler on hand.

MARKERS AND/ OR WATERCOLORS (OPTIONAL)

I like using 1 or 2 colors and adding them only in some areas of my doodles, leaving other areas blank. This "semi-coloring" method works for me because it takes less time to do, and it's also easy and fun. The chances of ruining my doodles are also reduced with semi-coloring. If you want to color your doodles, semi-coloring is a good practice and less intimidating for beginners.

PHOTOSHOP (OPTIONAL)

When I doodle using pen and ink and then scan the image, I use Photoshop to clean it and prepare a print-ready file. Sometimes, I also like to add colors to hand-drawn doodles digitally with Photoshop. Mixing the traditional and digital processes to create final artwork is also fun!

Tips & Tricks

Being a full-time doodle artist, I want to share the tips and tricks I have learned over time for creating kawaii characters.

- Sketch your characters with a mechanical pencil before inking them, especially more complex characters.

- When drawing square, rectangular, and pointy shapes, rounding corners and points always adds a cuter element to the character.

- Adding a simple face is always recommended, but if you don't have room, no worries. Faceless characters can also be cute!

- But if you prefer giving your characters a face, drawing their bodies or faces wider will give you more room to do this.

- Speaking of faces, go ahead and play around with the position of the face. You don't have to place the face in the center every time, or ever!

- Varying the distance between a character's eyes and mouth can really change the appearance of a facial expression.

- Drawing a nose, along with eyes and a mouth, can really add "character" to your characters.

- Once you have drawn your characters, feel free to adorn them with decorations (hearts, stars, speech bubbles, etc.). Visit the Doodle Directory on page 10 for inspiration!

- Most importantly, there are no right or wrong ways to doodle kawaii characters. Just experiment and try to come up with your own unique style with the help of this book!

Doodle Directory

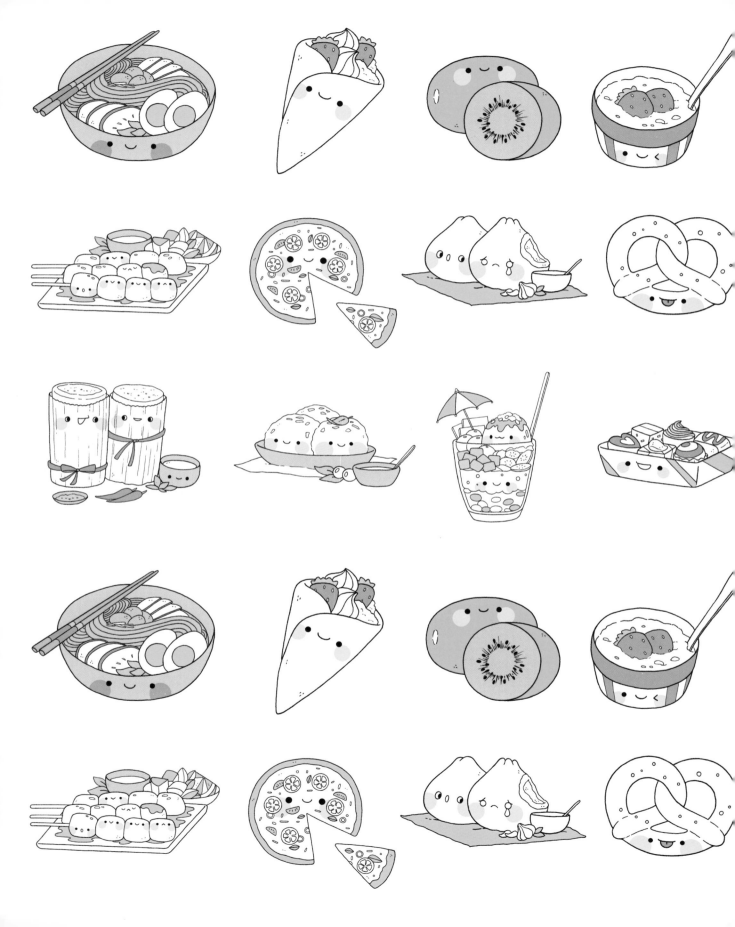

Adorable Food

Macaron

 France

1. Draw a semicircle.

2. Close the semicircle with a slightly curved line, with rounded edges extending past the sides.

3. Draw short, curved lines from the sides of the macaron top, for the filling.

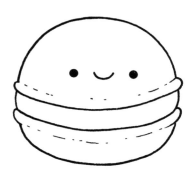

4. Draw the bottom of the macaron in the style of the top, but don't make it as deep and rounded.

5. With a fine point pen, draw dots and dashes on the top and bottom of the cookie to give it some texture.

6. Draw a cute face, of course!

Kiwifruit

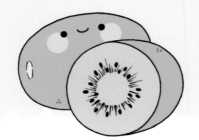

1. Draw a circle.

2. Draw a curved line off the right half of the circle, like a crescent moon.

3. Draw a partial oval off the left side of the kiwifruit half.

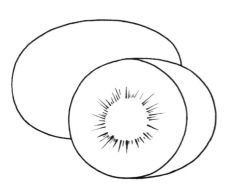

4. With a fine point pen, draw a series of lines of varying lengths in a circle, for the fruit's center.

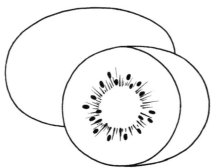

5. Now place some seeds throughout those lines.

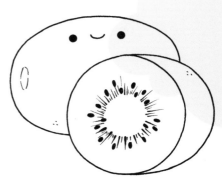

6. Add some dots and dashes to both kiwifruits for texture. Draw a cute face, of course!

Pizza

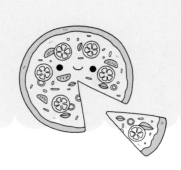

Italy

1. Draw an incomplete circle.

2. Complete the circle by drawing an inverted triangle, kind of like Pac-Man. Now draw a triangle of a similar size for the pizza slice.

3. Draw a second, slightly wavy line inside the first outline for the crust. Don't forget to add crust to the pizza slice!

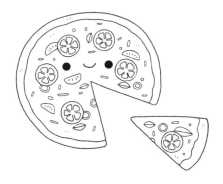

4. Draw a cute face, of course!

5. With a fine point pen, add your favorite toppings. I drew tomato slices, basil leaves, olives, and more! Add some dots along the crust and on the pizza for a little texture.

Yogurt

Greece

1. Draw an incomplete oval.

2. Draw a curved line from the bottom of the incomplete oval.

3. Draw a deeper curved line off this one to complete the base of the bowl.

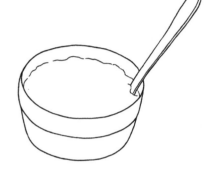

4. Draw a wavy line in the bowl for the yogurt. Complete the top oval by adding a spoon handle. Don't forget to add some lines where the spoon enters the yogurt!

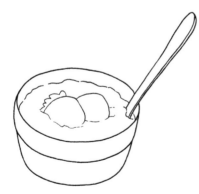

5. Draw a pair of strawberries, one with a stem, and some texture lines in the yogurt.

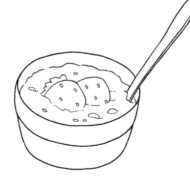

6. With a fine point pen, add seeds to the strawberries, along with some granola in the yogurt.

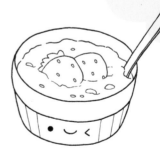

7. Draw a few vertical lines on the base of the bowl, leaving space for a cute face. Don't forget to draw that!

Crêpe

France

1. Draw a deep V shape, with a rounded point and curved lines at the top. Draw another curving line for a fold in the crêpe.

2. Draw a second curved line to complete the fold.

3. Fill the crêpe with your favorite fillings. I like custard, strawberries, and whipped cream! I added seeds to the strawberries and dots to the custard for texture with a fine point pen.

4. Finish by adding some dots to the crêpe for texture and drawing a cute face, of course!

Chocolates

1. Draw an L shape at an angle.

2. Draw a short, slanted line off each of the 3 edges. Connect these lines, making rounded corners.

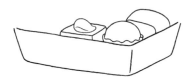

3. Begin building your box of 6 chocolates, starting with placement in the near corner and moving up and to the left. You can follow my chocolate styles or come up with your own!

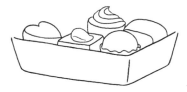

4. Keep adding those chocolates! Cubes, spheres, hearts, swirls . . .

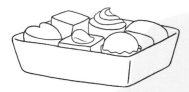

5. Once you have your 6 chocolates placed, draw lines on the left side and back of the box to complete it.

6. Draw a cute face, of course!

7. With a fine point pen, add details and decorate your chocolates and the box. Yum!

Pretzel

1. With a pencil, draw 2 interlocking shapes as guidelines for the pretzel.

2. Continuing with the pencil and starting at the bottom center, draw a fat pretzel shape around the guidelines. You should be able to do this in one continuous line, but it might take a few tries!

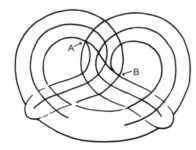

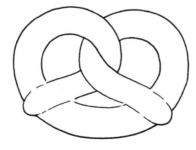

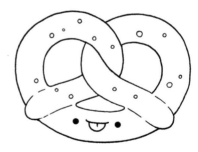

3. To create the pretzel twist, draw a line from point A to point B.

4. Erase any unnecessary pencil lines so your pretzel is clean like my drawing. Use a pen to ink the remaining lines.

5. Draw a cute face, of course! With a fine point pen, draw small circles for salt.

Satay

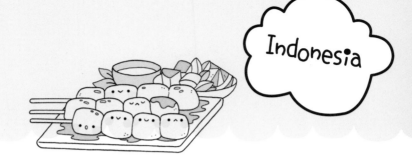

1. Draw a cube shape, with rounded corners, followed by 3 more of these shapes, all connecting.

2. Add a stick with a rounded point.

3. Draw 2 more rows of skewers behind the first one. These only need to show the top halves except for the ones sticking out on the ends.

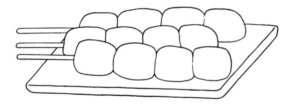

4. Draw a platter for your satay to sit on.

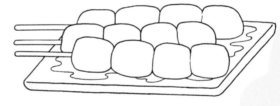

5. Add some sauce to the platter.

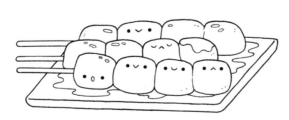

6. Draw cute faces, of course! With a fine point pen, add some small ovals and dots to give the satay texture. Also add some sauce on top of one piece of meat.

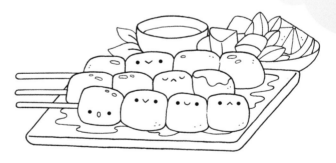

7. Don't forget to serve it with sauce, lime, cucumber segments, and fresh herbs!

Meatballs

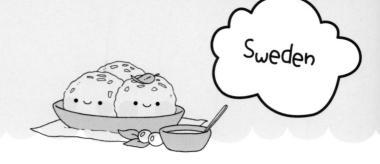

1. Draw 2 short lines that curve out and then in again. Connect these lines to make the bowl.

2. On the right side of the bowl, draw a lumpy semicircle for a meatball. Top it with a leaf.

3. Add another meatball to the left side of the bowl that touches the first meatball. Draw the top of a third meatball behind the first two.

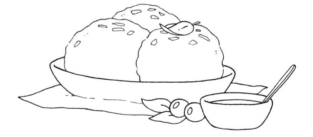

4. With a fine point pen, give the meatballs texture with some dots and small geometric shapes.

5. Add a napkin underneath the bowl, along with a bowl of sauce (with a spoon) and some berries as garnish.

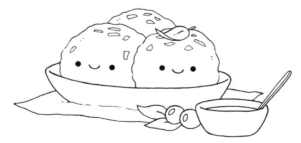

6. Draw cute faces, of course!

Tamales

Mexico

1. Draw 2 connected semicircles with tiny scalloped edges.

2. Draw 3 vertical lines from the edges of the semicircles, leaving a small opening in the line on the right.

3. Complete the bottoms of the corn husks. Add bows and/or ties around the corn husks.

4. Add some delicious filling to the husks, drawing circles and giving the one on the left a little more detail.

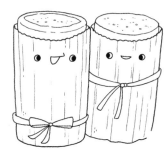

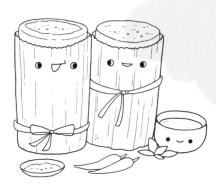

5. Draw cute faces, of course!

6. With a fine point pen, add dots and small circles to the filling and draw vertical lines on the husks for texture.

7. Don't forget the condiments!

Adorable Food 23

Dumplings

1. Draw a line with puckers.

2. Draw curved lines off this line as if drawing a fat, incomplete pear. On the right side, draw a shape to replicate a bite taken out of the dumpling.

3. Give more detail to the "bite" with another bite shape inside. With a fine point pen, add dots for texture.

4. Draw a second dumpling off the first one.

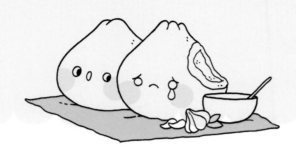

5. Draw cute (or sad) faces, of course!

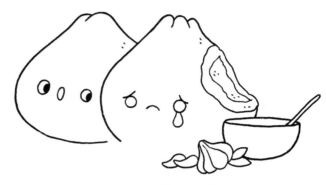

6. With a fine point pen, add a couple dots to the top of each dumpling for texture. Don't forget the condiments! I drew a bowl of sauce, garnished with a garlic head and cloves.

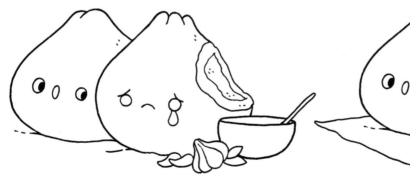

7. Close up the dumpling on the right and add a dashed, curved line coming off the bottom of each one.

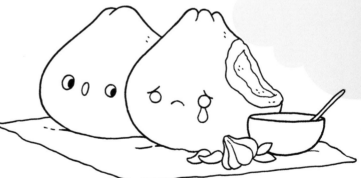

8. Finish by placing your dumplings and condiments on a napkin.

Halo-Halo

1. Draw a U shape that is flatter than normal on the bottom, making rounded corners.

2. Add a line at the top and bottom of this shape to define the glass shape. Give curved ends to the top edges of the U shape.

3. Add a scoop of *ube* (purple yam) ice cream, topped with *pinipig* (flattened roasted rice).

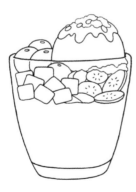

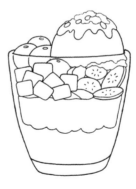

4. Add the next layer of gelatin cubes and tropical fruits, such as lychee, mango, kiwi . . . whatever you want! (Note: When adding the layers to the glass here and in the next steps, leave some room on each side and the bottom to give the glass some heft.)

5. The next layer is the shaved ice and evaporated milk.

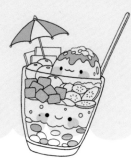

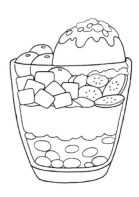

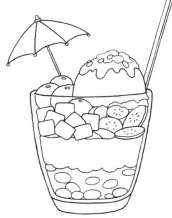

6. Add the final layer of sweetened kidney beans and chickpeas.

7. Draw a spoon handle and a fun drink umbrella.

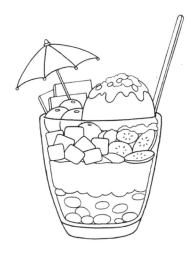

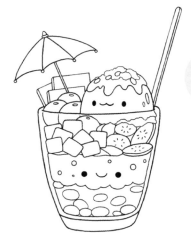

8. Why not add some cookie wafers?

9. Add some bubbles to the middle layer and some texture to the ice cream. And draw cute faces, of course!

Ramen

1. Draw an oval.

2. Lay chopsticks (page 116) on top of the oval.

3. Draw a curved line to complete the bowl shape.

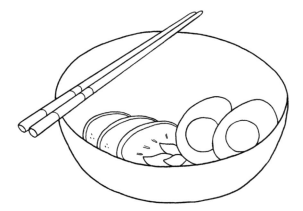

4. Add the toppings at the near side of the bowl. I drew egg halves, meat pieces, and some greens. With a fine point pen, draw dots and dashes to give the meat texture.

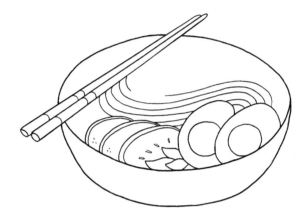

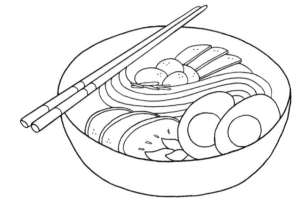

5. Continuing with the fine point pen, draw some swirling lines for the noodles.

6. Add more toppings to the far side of the bowl. I drew bamboo shoots, mushroom tops, and some seasoning. With a fine point pen, draw groups of dots to give the bamboo shoots and mushrooms texture.

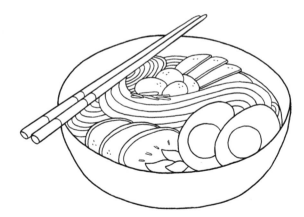

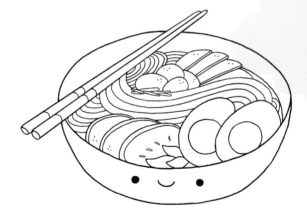

7. Fill in any remaining spaces in the bowl with swirling lines of noodles drawn with a fine point pen.

8. Draw a cute face, of course!

Get Inspired

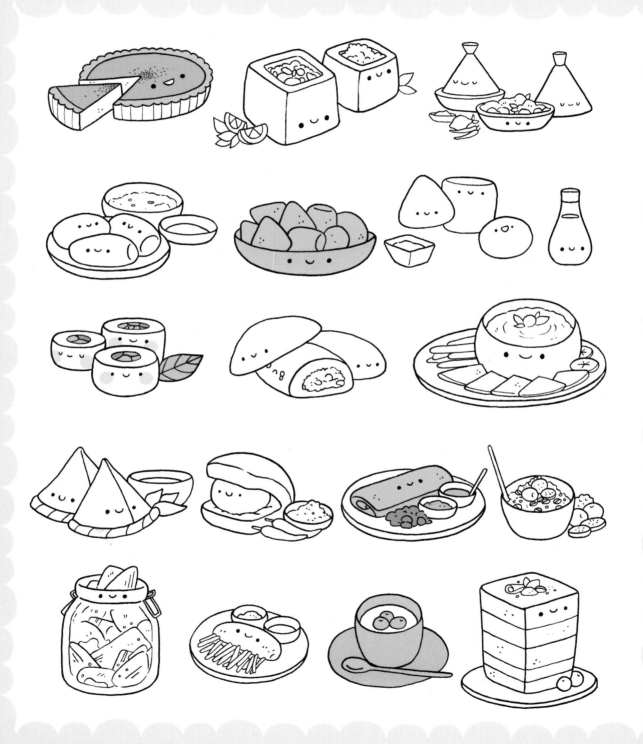

Here are some more of my kawaii food (and drink!) doodles to inspire you. The world has so much to offer with its many cuisines. Get ready to try new things!

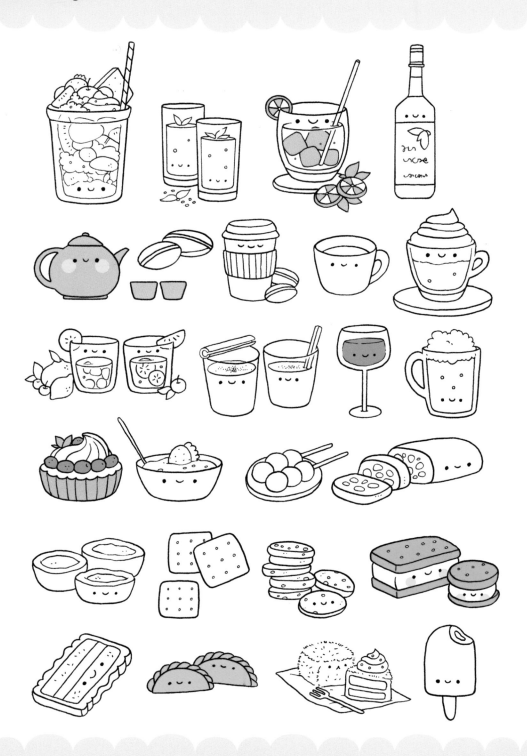

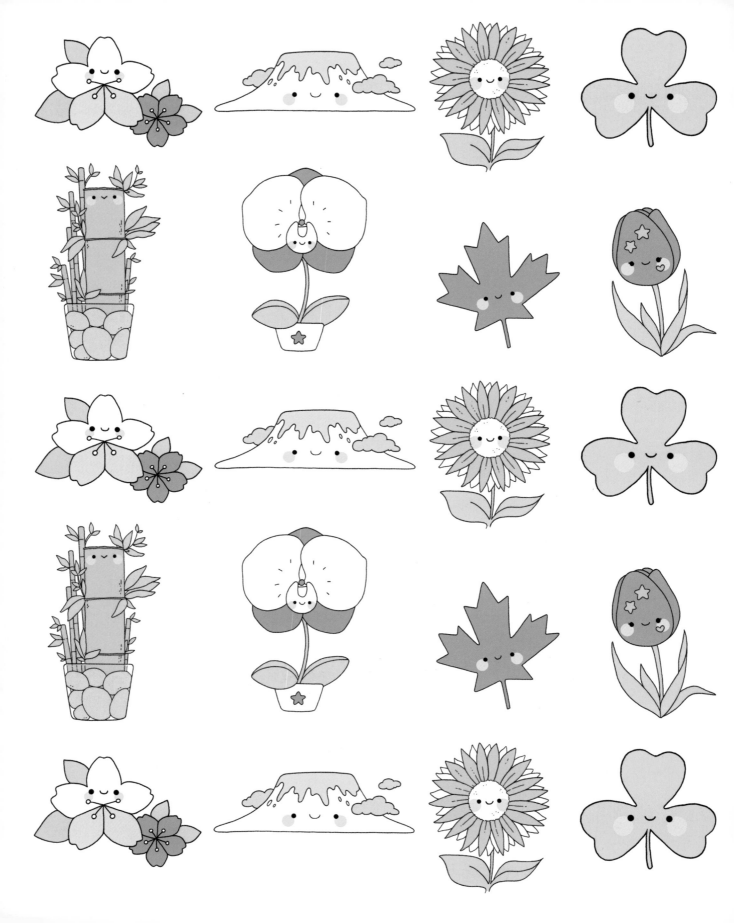

Precious Nature & Natural Wonders

Mount Kilimanjaro

 Tanzania

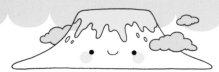

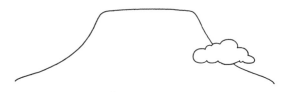

1. Draw a wide mountain shape, leaving the bottom open. Add a fluffy cloud on the right side.

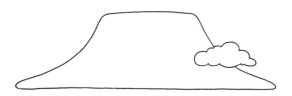

2. Close up the mountain with a straight line that has pointy yet rounded edges.

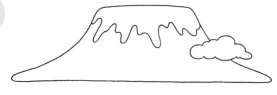

3. Add a snowcap to the mountain, kind of like dripping paint.

4. Add a couple more clouds and some ovals of snow farther down the mountain.

5. Draw a cute face, of course!

Shamrock

Ireland

1. Draw a heart shape, leaving its bottom open.

2. Draw 2 more connecting heart shapes, leaving an opening at the bottom for the stem.

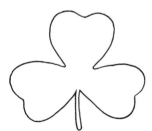

3. Add a stem with a rounded point.

4. Draw a cute face, of course!

Tulip

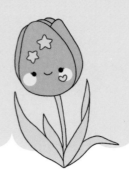

The Netherlands

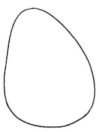

1. Draw an egg shape.

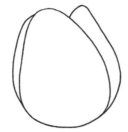

2. Draw a curved line off each side of the egg shape for petals.

3. Add 2 small arcs at the top for more petals.

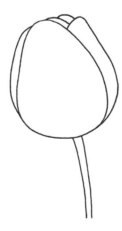

4. Draw a stem, leaving it open at the bottom.

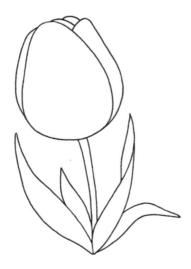

5. Add long leaves at the base of the stem.

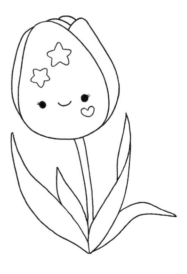

6. Draw a cute face, of course! Decorate your tulip with some doodle elements. I drew a heart and chubby stars.

Sunflower

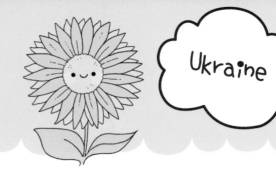

Ukraine

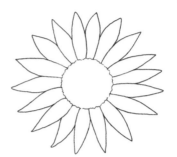

1. Draw a circle, giving the line a little texture.

2. Draw a shape, like a feather, off the top of the circle.

3. Continue drawing these featherlike shapes around the circle, overlapping one another a bit.

4. Make a second row of petals by drawing in 1 or 2 upside-down V shapes between the first layer of petals.

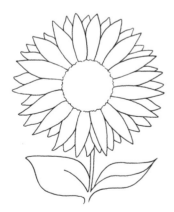

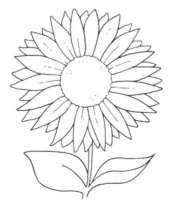

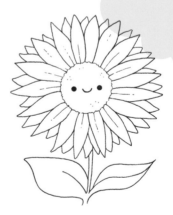

5. Draw a stem and a couple of leaves.

6. With a fine point pen, draw dots and dashes on the circle and first layer of petals to give the sunflower some texture.

7. Draw a cute face, of course!

Maple Leaf

Canada

1. Using a pencil, draw a line at an angle.

2. Continuing with the pencil, draw a large V shape and then a smaller upside-down V shape a little past halfway down the angled line. These are your guidelines.

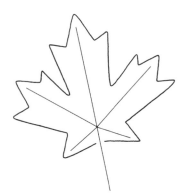

3. Following the points of your guidelines, draw the leaf shape around them with a pen.

4. Erase the pencil guidelines and add a stem.

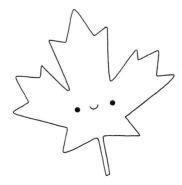

5. Draw a cute face, of course!

Orchid

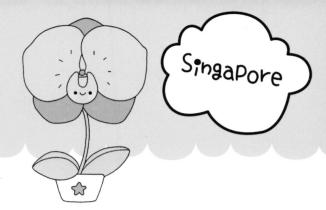

1. Draw a fat horseshoe shape with a circle and lines closing off the top.

2. Draw a large, rounded petal off the right side of the orchid's center.

3. Draw a second petal off the left side, making sure the first petal slightly overlaps it.

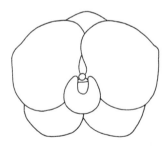 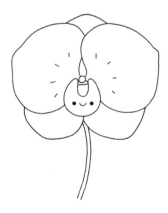

4. Add 3 more incomplete petals behind the original petals: 1 peeking out the top and 2 at the bottom.

5. Add a stem that is open at the bottom and draw a cute face, of course! Add some short vertical lines with a fine point pen to give the inner petals texture.

6. Finish with a pair of leaves and a cute little pot decorated with a doodle element. I drew a chubby star.

Cherry Blossom

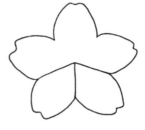

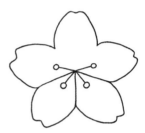

1. Draw an upside-down U shape with a slight indent at the top.

2. Add 2 "arms" to the U shape, followed by 2 "legs."

3. Draw 3 lines to define the "legs."

4. At the top, where these lines connect, draw 4 lines (the filaments) in different directions with circles (the anthers) on the ends.

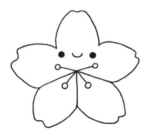

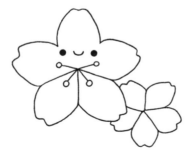

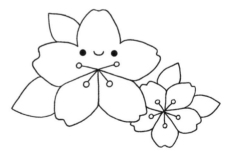

5. Draw a cute face, of course!

6. Draw a smaller cherry blossom off the right "leg" so that it sits a little bit behind this leg. Draw 5 lines within the smaller cherry blossom to define the petals.

7. Add 5 filaments and anthers to the smaller cherry blossom, and leaves to both flowers.

Volcano

Costa Rica

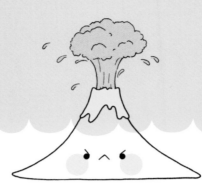

1. Draw a short, wavy line with lines that curve out off the sides.

2. Complete the crater with a line of dripping lava.

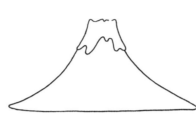

3. Continue the curving lines on both sides for a wide mountain shape, then close it up with a straight line that has pointy yet rounded edges.

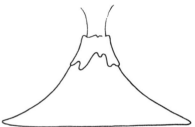

4. With a fine point pen, draw 2 short concave lines coming out of the crater.

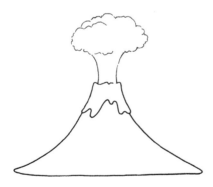

5. Continuing with the fine point pen, draw a mushroom cloud.

6. Add detail to the cloud, along with spewing lava off the sides.

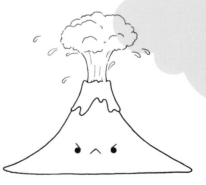

7. Draw a cute face, of course!

Bamboo

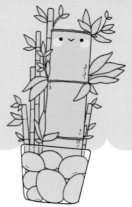

1. Draw a very narrow rectangle, making the lines bumpy.

2. Draw a longer straight line down the right side and a line half the length of that one on the left side. Complete the bottom of the bamboo segment with a rectangle like you drew in step 1.

3. Add lots of little leaves, filling in the open space on the left side.

4. Draw another complete segment with a grouping of leaves on the bottom left, followed by a segment that is incomplete and only a quarter of the length of the other two.

5. Draw an upside-down trapezoid for the planter, making rounded corners.

China

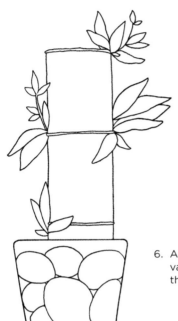

6. Add oval rocks of varying sizes to the planter.

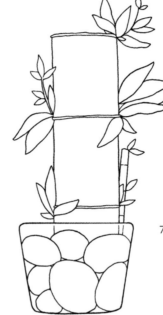

7. Extend the bottom bamboo segment into the rocks and add a little bamboo shoot on the right.

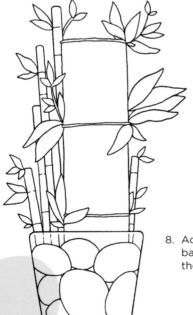

8. Add even more little bamboo shoots to the planter.

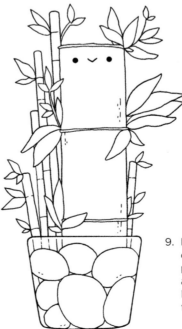

9. Draw a cute face, of course! With a fine point pen, draw dots and dashes on the large shoot and rocks for texture.

Precious Nature & Natural Wonders 43

Great Barrier Reef

This drawing is simpler than it looks! Don't worry about following my drawing exactly and have fun drawing your own Great Barrier Reef.

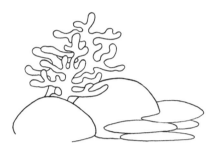

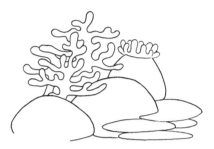

1. Draw a rock shape with some coral coming off it. Don't be afraid to get a little wild when drawing coral!

2. Keep adding rocks and coral to your scene, building it up and to the sides.

3. Add sea anemone.

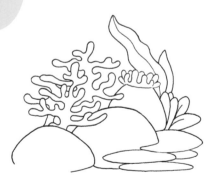

4. Why not add some plants and kelp to the scene? Draw the kelp so it looks to be waving in the water.

5. Continue adding to the scene with some sponges of varying heights.

6. Fill in some open background space with more kelp.

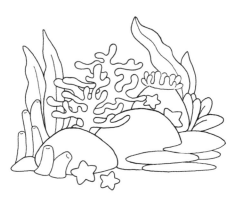

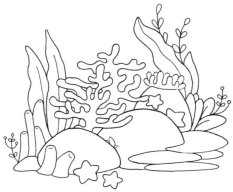

7. At this point, I decided to add some doodle elements, such as chubby stars. Have fun with your underwater scene!

8. With a fine point pen, add more underwater plants with delicate leaves.

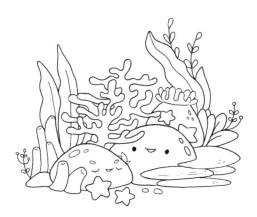

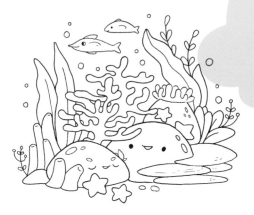

9. Continuing with the fine point pen, draw small ovals, dots, and dashes to give your rocks texture. Draw cute faces, of course!

10. Finish with some fish and bubbles.

Get Inspired

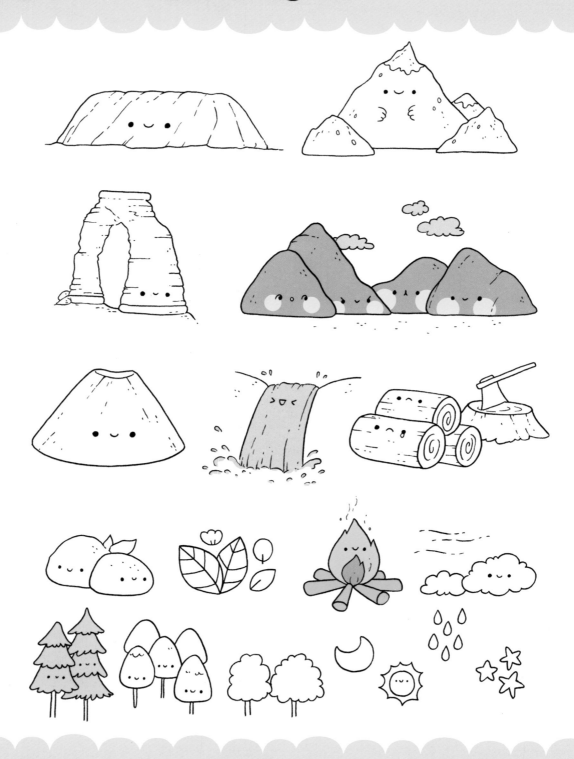

Here are some more of my kawaii nature and natural wonder doodles to inspire you. Can you believe that all of these things were created naturally, with some being around for millions of years?!

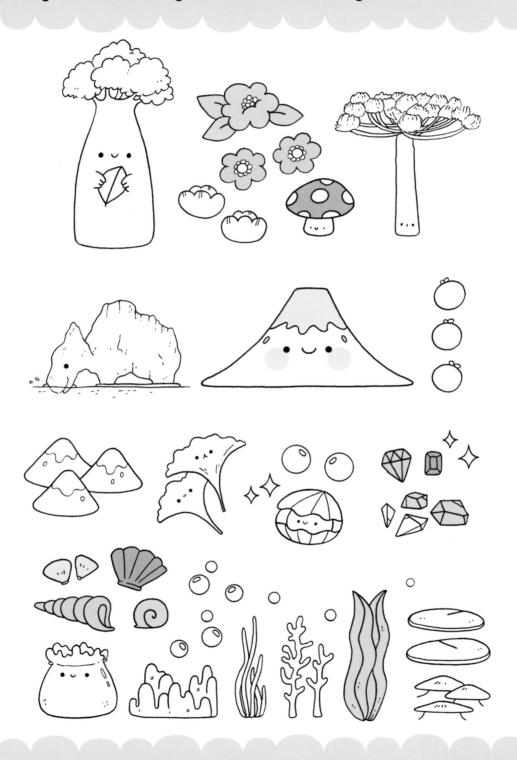

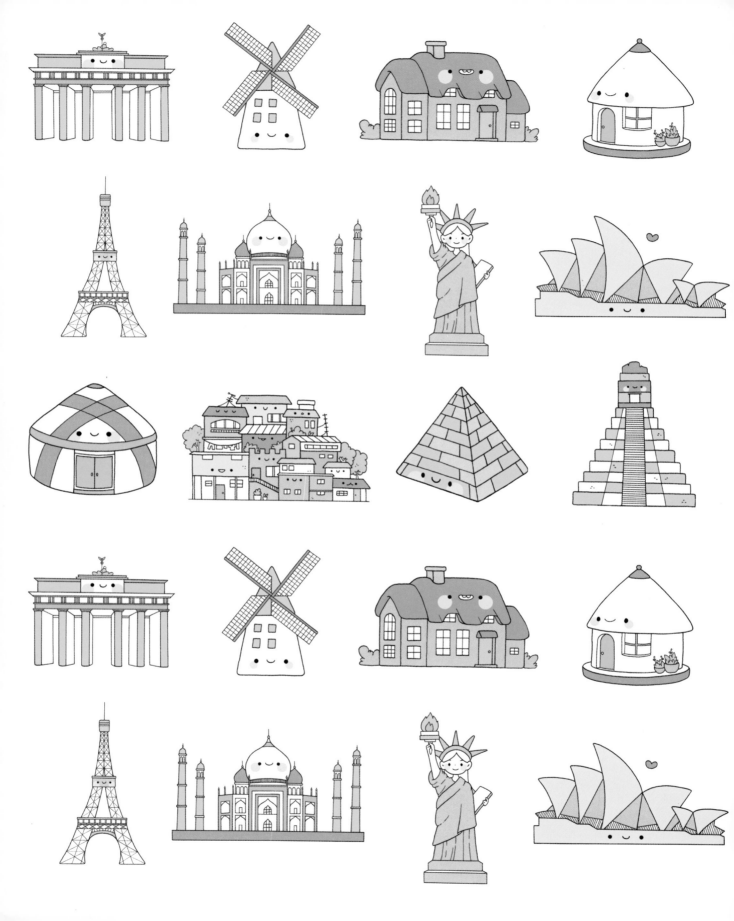

Enchanting Architecture & Monuments

Great Pyramid of Giza

1. Draw an upside-down V shape at a slight angle.

2. Draw an angled line off the point of the V shape.

3. Complete the shape by joining the sides.

4. On the left face of the pyramid, draw equally spaced horizontal lines.

 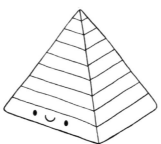 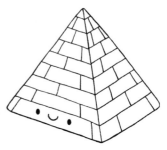

5. Continue drawing horizontal lines on the pyramid's right face, lining them up with those on the left face.

6. Draw a cute face, of course!

7. To replicate bricks, add vertical lines within the horizontal lines. See how the placement of these lines alternates on the left and right faces?

8. Continue adding alternating vertical lines to complete the pyramid.

Yurt

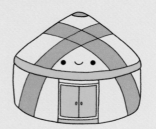

Mongolia

1. Draw a wide upside-down V shape with a rounded point.

2. Connect the sides of the V shape, making rounded corners. Also draw a short, curved line at the top point of the triangle.

3. Draw straight lines from the sides of the triangle and connect the sides, making rounded corners.

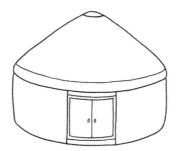

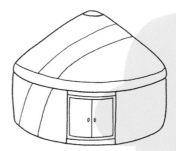

4. Draw a line that runs parallel to the where the roof and base meet. Also, draw the doorway.

5. Draw 2 doors with doorknobs.

6. Draw parallel lines that run diagonally from the roof to the ground.

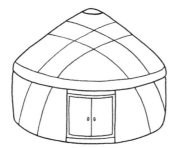

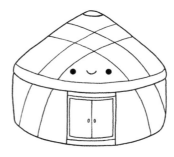

7. Repeat step 6 but with the parallel lines running in the opposite direction.

8. Draw a cute face, of course!

Windmill

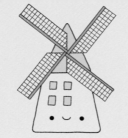

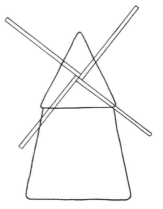

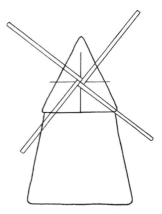

1. Draw a triangle, making rounded corners, then draw a 3-sided trapezoid underneath, also with rounded corners. (Draw the triangle in pencil, as you will need to erase lines in a later step. You can ink it then.)

2. With a fine point pen, draw an X shape at a slight angle, making sure the center of the X falls in the center of the roof.

3. Continuing with the fine point pen, add parallel lines to the 4 lines of the X shape and connect each one with a rounded edge.

4. Keep using the fine point pen and make a cross shape with the center being where the lines in step 3 meet.

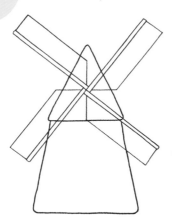

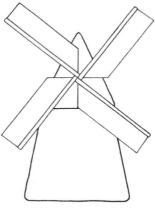

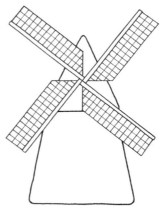

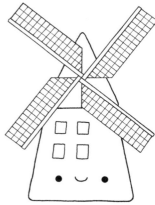

5. Add blades to the lines from step 3. These are kind of like 3-sided rectangles, but the inner line is slanted instead of straight.

6. Erase the pencil lines within the blades. Make sure to look closely at my drawing while you do this.

7. With a fine point pen, make a grid pattern on the 4 blades.

8. Add some windows and a cute face, of course!

Rondavel

South Africa

1. Draw an incomplete triangle with rounded corners.

2. Draw a smaller triangle for the point with a tiny circle on top.

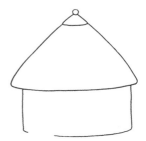

3. Draw 2 straight lines from the roof, a little in from the edges. Connect these lines with an incomplete line, making rounded corners.

4. Draw an outer line for the base that curves around the house.

5. Draw a line below this one that runs parallel to it, for the foundation.

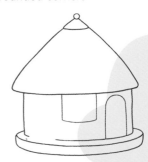

6. Add a window and an arched doorway to the house.

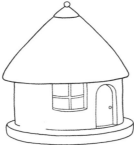

7. Give the window and doorway more detail and depth.

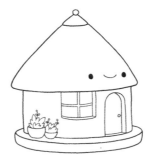

8. Finish with some plants and a cute face, of course!

Eiffel Tower

Though I get detailed in this doodle, feel free to make your Eiffel Tower as simple or detailed as you want. Look closely at my drawings to capture all the details!

France

1. There are 3 sections to the Eiffel Tower, so draw the in-between structures first, which are rectangles of varying sizes, going from smaller at the top to wider at the bottom.

2. Draw the outline of the latticework; at the top, it is narrow and together, splaying out wider toward the base. Also add more details to the structures in between and add lines to the base.

3. Start the latticework by drawing horizontal lines down the entire structure.

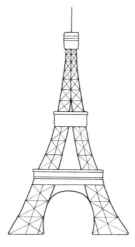

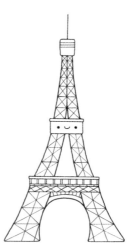

4. Between the horizontal lines, draw X shapes to fit the spaces. Once you have finished doing this, draw vertical lines down the centers of the Xs, but only in the bottom 2 segments, not the top segment.

5. Add more details to the bottom in-between structure. Make sure to look closely at my drawing. Draw a cute face, of course!

Thatched-Roof Cottage

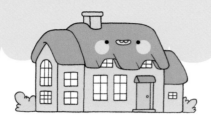

1. Draw a roof that is very rounded at the edges, to give the feel that it is made of straw, leaving the side incomplete. Don't forget the chimney!

2. Close up the side by drawing a line with 2 notches in it.

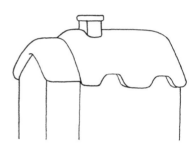

3. Draw 4 vertical lines for the outline of the cottage. Also add lines to the right sides of the roof notches.

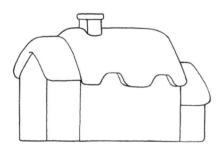

4. Add a little addition with a roof off the back of the cottage. Draw a horizontal line from front to back for the cottage's base.

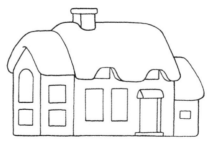

5. Draw windows of varying sizes and shapes, and a door with a small awning and a step. Don't forget to add windows in the roof notches!

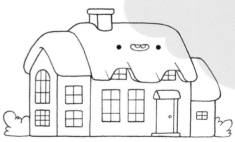

6. Add panes to all the windows and a doorknob to the door. With a fine point pen, add some lines to the roof for texture. Decorate the outside of your cozy cottage with bushes, if you like. And draw a cute face, of course!

Tikal

1. Draw a rectangle with the bottom line extending farther out than the sides.

2. Using a pencil, draw 3 guidelines, with 2 of them slanting out from the bottom of the rectangle and the third straight down the center.

3. Going pack to using a pen, draw 2 slightly slanted lines on either side of the center pencil line.

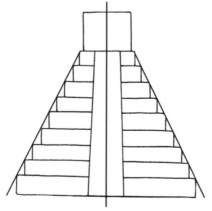

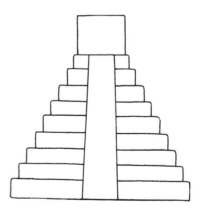

4. Draw equally spaced horizontal lines between the inner and outer slanted lines, finishing with a long base line.

5. Add vertical lines between the edges of the horizontal lines, like steps.

6. Erase the 3 pencil guidelines.

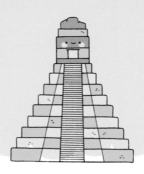

Guatemala

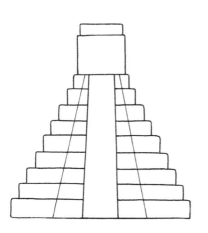
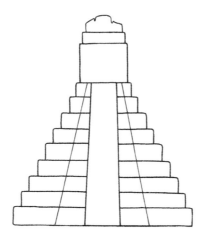
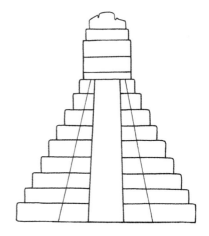

7. Draw 2 slanted lines from the bottom of the top rectangle to the base of the structure. Add a 3-sided rectangle on top of the top rectangle.

8. Add a jagged stone on top of this rectangle.

9. Draw 2 horizontal lines in the rectangle from step 1.

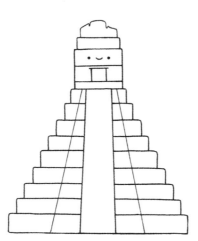
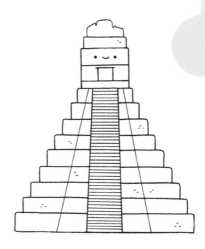

10. Draw a doorway in this rectangle, along with a cute face, of course!

11. With a fine point pen, add groups of dots onto the structure to give the stone some texture.

Taj Mahal

Though I get detailed in this doodle, feel free to make your Taj Mahal as simple or detailed as you want. Look closely at my drawings to capture all the details!

1. Draw 3 vertical, connecting rectangles, with the middle one taller and wider than the matching pair on the sides.

2. Add another rectangle to each side rectangle, the same size and shape, but draw these so they look like they're bending, kind of like a folding screen.

3. Draw 8 *guldastas*, or decorative spires, on top of the edges of the rectangles.

4. Draw a large onion dome, with a finial on top, off the 2 center guldastas. Also add a structure on each side of the onion dome. Make sure to look closely at my drawing!

5. Top the structures added in the previous step with smaller onion domes and finials.

6. Start adding carved details in rectangular shapes to the façade of your Taj Mahal and to the top and bottom of the large onion dome. The smaller onion domes top a columned area (this columned structure with a dome on top is called a *chattri*).

7. Add arches to the rectangular details you drew in the previous step.

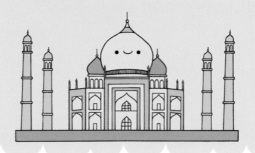

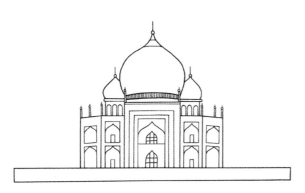

8. Add windows to some of the arches from step 7. Draw a long, narrow rectangle for the base of the building. Make sure it is long enough for the 2 minarets that will go on each side of the building.

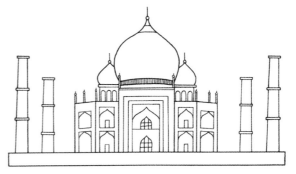

9. Draw the bases of the 4 minarets—each one is segmented into 3 sections. Draw the inner minarets shorter because they are behind the outer ones.

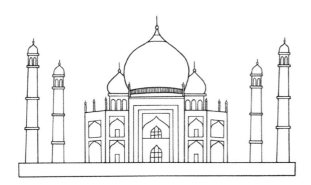

10. Look closely at my drawing to get the details for topping the bases of the minarets.

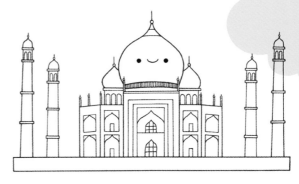

11. Draw a cute face, of course!

Enchanting Architecture & Monuments 59

Tiny Colorful Homes

This drawing is simpler than it looks! Don't worry about following my drawing exactly and have fun drawing as many tiny homes together as you like.

1. Draw a horizontal line that will be the length of your scene. Start building on this line with a simple rectangle, then add more lines for multiple structures and roofs.

2. Keep building on your original rectangle, drawing up and to the sides. Add different details for the roofs and building shapes. Just make sure the houses are all connected and close together.

3. Keep on adding tiny houses. I even added a chimney to one!

4. Draw a bunch of cute faces, of course! Make them unique from one another.

Haiti

5. Add the outlines of windows, doors, and even stairways.

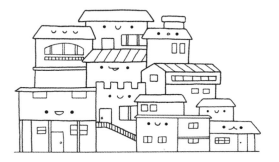

6. Give your windows, doors, stairways, and rooftops details.

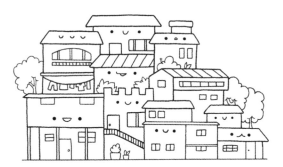

7. Now you can have a lot of fun! Add in even more details, like trees, plants, clotheslines, or anything else you want to include.

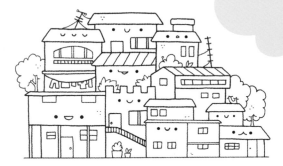

8. Finish with any final details. I added some TV antennas! With a fine point pen, add groups of dots throughout to give the homes and trees some texture.

Enchanting Architecture & Monuments 61

Sydney Opera House

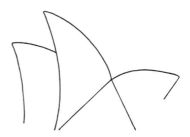

1. Draw a finlike shape.

2. Draw a smaller finlike shape off the first one.

3. Extend slanted lines down from the 2 fins and draw another fin off the left side of the original fin.

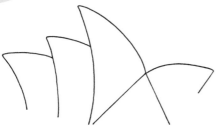

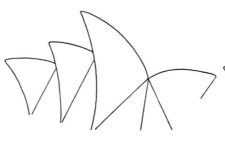

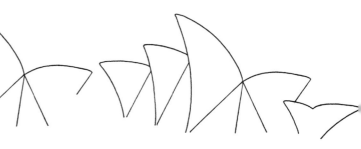

4. Draw another fin off the one you just added.

5. Add another line to each of the 2 fins on the left to turn them into triangles. Extend another slanted line from the original fin.

6. Overlap the fin on the far right with a shape like a mermaid's flipper.

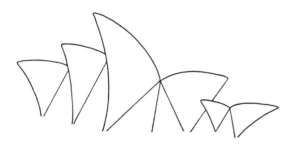

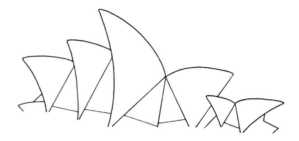

7. Now turn that mermaid flipper into 2 triangles by bisecting it with 2 slanted lines.

8. Look closely at my drawing and mimic the horizontal and other lines I've added to the structure.

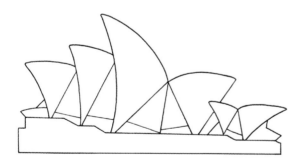

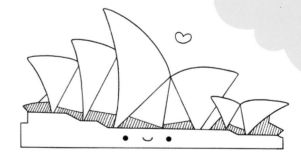

9. Draw the building's base, with it starting wider on the left side and narrowing on the right. Follow the bottoms of your triangles, overlapping their points.

10. With a fine point pen, fill in the spaces between the lines drawn in step 8 and the building's base with a bunch of slanted lines drawn closely together. Finish with a cute face, of course! I also added a heart as a doodle element. Feel free to add your own doodle element.

Statue of Liberty

Though I get detailed in this doodle, feel free to make your Statue of Liberty as simple or detailed as you want. Look closely at my drawings to capture all the details!

1. Start the face by drawing the ears and connecting them with a rounded chin.

2. From the ears, draw a wide, upside-down V shape. Also draw a narrow neck with 2 short, concave lines.

3. Draw a semicircle to complete the top of the head, then draw a line parallel to that one for the base of the crown.

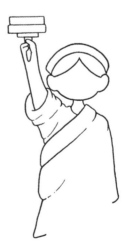

4. Start drawing the robe, making sure there are indents on the sides, along with diagonal lines extending from these indents on the left side, to give the effect of folds.

5. For this step, look closely at my drawing. Continue drawing the robe on the left side of the body. See how the sleeve bunches around the upper arm because the arm is going to be raised? Use a fine point pen to add the lines for the folds. Now draw the extended arm with a closed fist that's going to be wrapped around the torch.

6. Draw the base of the torch as 3 rectangles of varying sizes, stacked upon one another. Don't forget the handle that should extend to the palm of the hand.

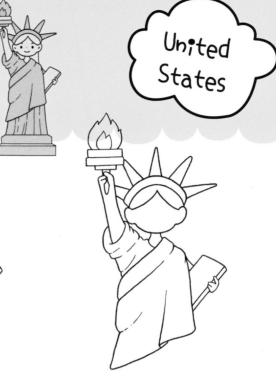

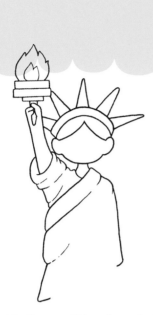

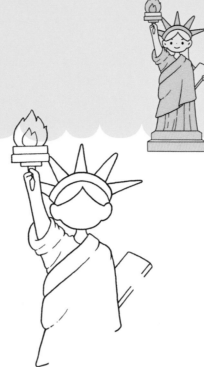

7. Add a flame within a flame to the torch. Draw 5 spikes on the crown as upside-down V shapes. The left-side spikes will be incomplete as they fall behind the torch.

8. Draw a tablet off the right side of the body, leaving open space on the side where the hand will go.

9. Draw a line for the upper arm and add in the fingers around the tablet. Close up the top tier of the robe. Draw a slanting vertical line for a fold.

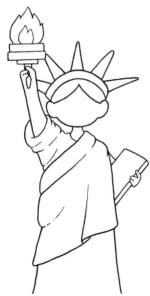

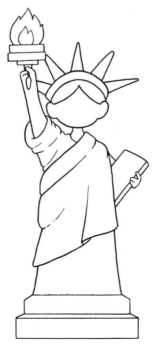

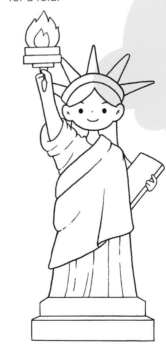

10. Draw 2 outwardly curving lines from the robe's top tier for the bottom tier.

11. Draw the base of the statue using rectangles, kind of like a pair of steps.

12. Draw a cute face, of course! Use a fine line to draw the vertical lines to make folds in the bottom tier of the robe, and give the ears definition.

Brandenburg Gate

Though I get detailed in this doodle, feel free to make your Brandenburg Gate as simple or detailed as you want. Look closely at my drawings to capture all the details!

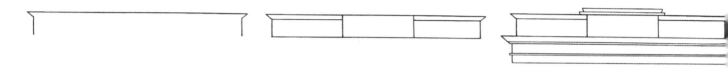

1. Draw a 3-sided rectangle with pointy corners.

2. Add architectural detail by closing the rectangle and drawing vertical lines in the center to divide this structure into 3 parts. Add horizontal lines at the tops of the right and left sides.

3. Keep adding rectangles to give the structure even more detail. Make sure to look closely at my drawing.

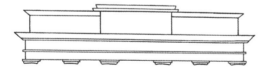

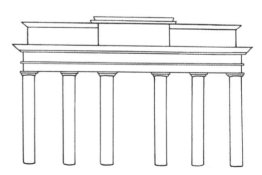

4. Finish this top structure by adding very narrow parallel-line details in the lower part and drawing the tops of the 6 Doric columns underneath.

5. Draw the Doric columns, giving them rounded corners.

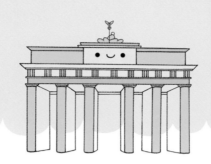

Germany

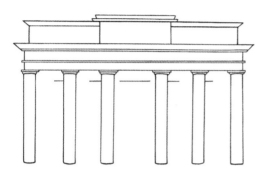

6. Draw horizontal lines near the tops of the 4 inner columns.

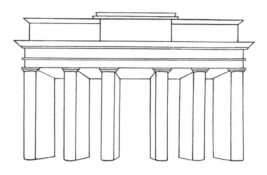

7. See how I've drawn six 3-sided rectangles that connect to the lines drawn in the previous step?

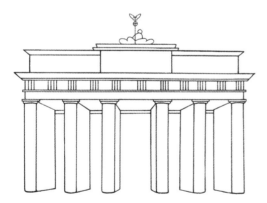

8. Draw the statue at the top. I kept this simple, but on the actual Brandenburg gate, this statue is of the Roman goddess Victoria driving a 4-horse chariot. On the frieze of the top structure, draw groups of small vertical lines.

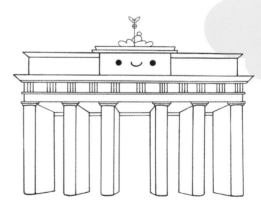

9. Draw a cute face, of course!

Get Inspired

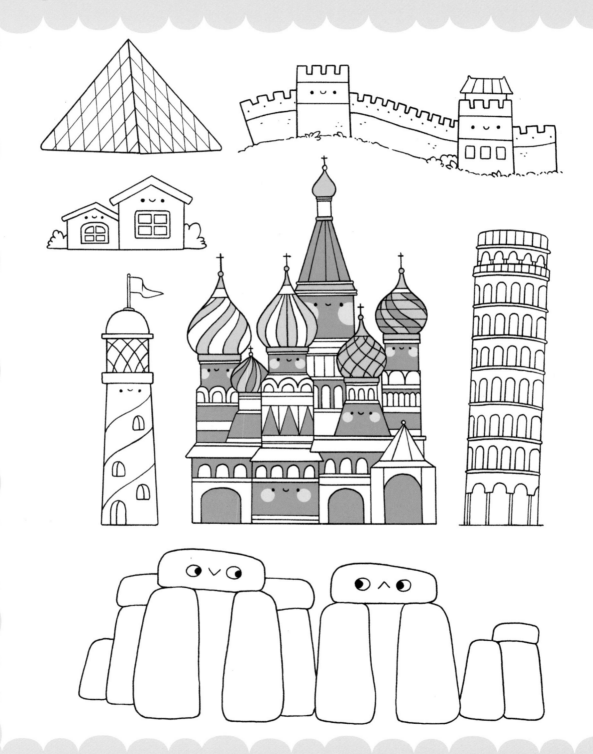

Here are some more of my kawaii architecture and monument doodles to inspire you. There are so many places to visit! Where would you like to go?

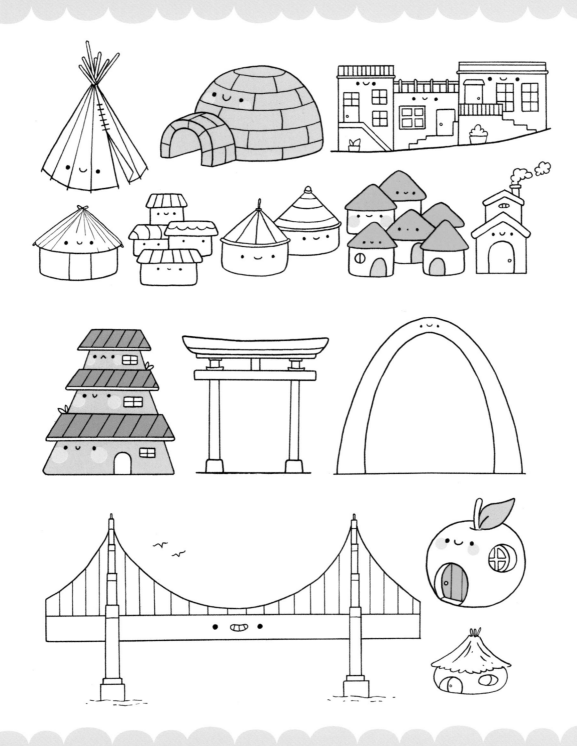

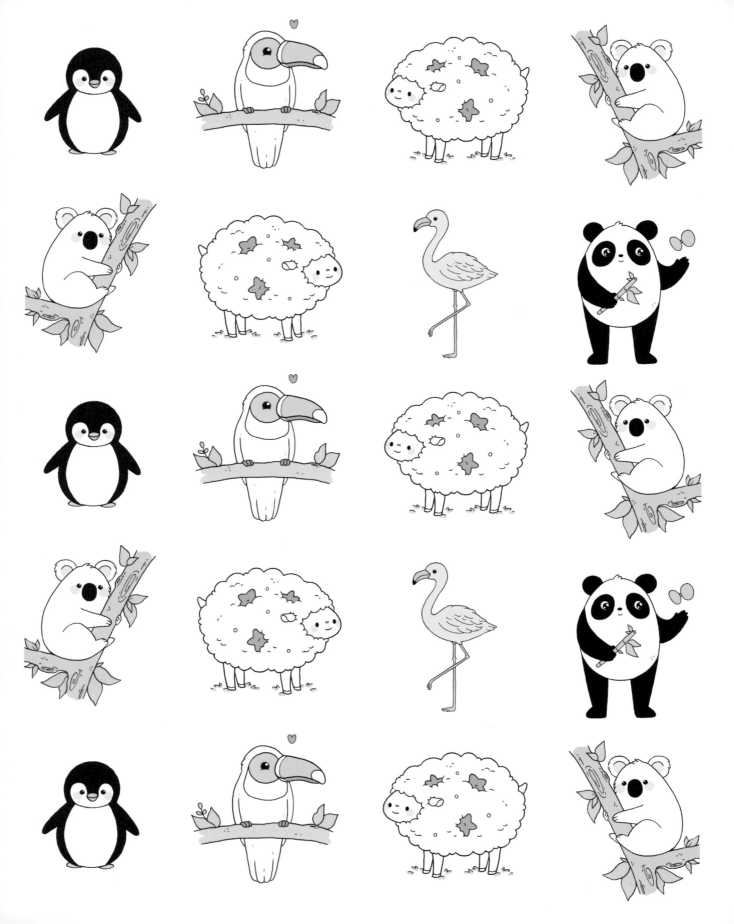

Lovable Animals & Birds

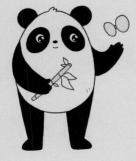

Penguin

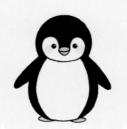

1. Draw an incomplete circle for the penguin's head.

2. Leaving a little space below the incomplete circle, draw a rotund U-shape for the penguin's body.

3. Draw the flippers from the open space between the head and body.

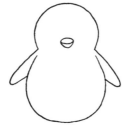

4. Draw the beak, giving it a rounded shape.

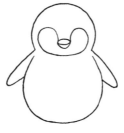

5. Using the beak as your guide, draw the face detail that will remain white.

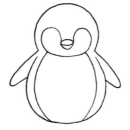

6. Draw 2 curved lines that run parallel to the body shape to define the white area of the body.

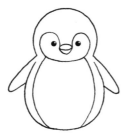

7. Draw 2 small circles for the eyes, then with a fine point pen, draw a very small circle within each eye. Color the eyes in black, leaving the smaller circles white for "shining" eyes.

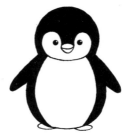

8. Add the feet and color the outer parts of the penguin in black.

Sheep

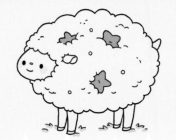

1. Draw a super-fluffy cloud shape, keeping the right side open.

2. In the open space, draw a sideways, U shape.

3. Close up the U shape with some fluffy fur.

4. Draw an ear that looks kind of like a potato chip.

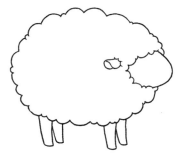

5. Draw 4 little legs.

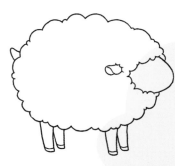

6. Add lines to the bottoms of the legs, for hooves, and draw a little nubbin of a tail.

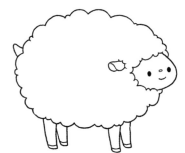

7. Draw a cute face, of course!

8. With a fine point pen, add dots, dashes, and circles to the fur for texture. Have fun with adding doodle elements to your sheep! I added chubby stars "sunk" into the fur. I also added some grass.

Giant Panda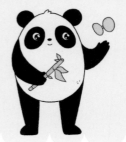

1. Draw a semicircle with some tufts of fur on top.

2. Add 2 round ears.

3. Extend the semicircle with slanted lines, adding a paw with claws on the left side.

 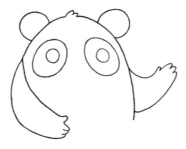

4. Complete the paw on the left side, then draw a paw with claws on the right side.

5. Draw a pair of eyes that kind of look like fried eggs.

6. Draw large pupils within the smaller circles.

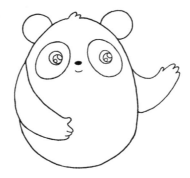

7. Now draw 2 small semicircles within each pupil. Once the pupils are colored in black, these circles will be left white to give an effect of "shining" eyes, making them more noticeable.

8. Finish the body with a very rotund egg shape and draw a cute face, of course!

9. Add some cute legs in proportion to the body.

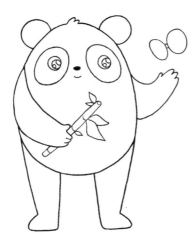

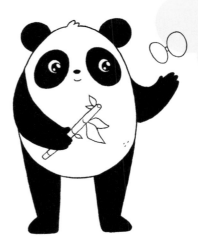

10. I included some extra elements such as bamboo (page 42) and a simple butterfly, but add anything you want.

11. Color the ears, arms, legs, eye patches, and pupils (leaving the semicircles white) in black. With a fine point pen, add a group of dots on the lower body to give the fur texture.

Lovable Animals & Birds 75

Koala

1. Draw a semicircle with some tufts of fur on top.

2. Extend the left line into a rounded egg shape for the body. Draw a bumpy, slanted line a little to the right of the body that goes about halfway down the body

3. Extend the right line of the semicircle to touch the slanted line, and include some tufts of fur where it meets.

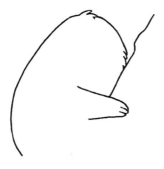

4. Draw a paw with claws that extends past the slanted line.

5. Complete the body with a nice, round haunch and a foot with claws.

6. Extend the slanted line between the paw and haunch. Draw another bumpy, slanted line off the back of the haunch.

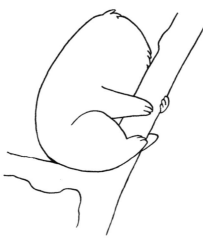

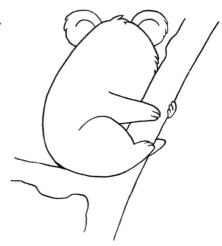

7. Draw more lines, parallel to the ones already drawn, for tree branches. Make them extra bumpy in places. Also extend them downward, below the koala. Leave an opening up near the right paw.

8. In that opening, draw claws that are reaching around the tree branch. Also draw the tip of a left foot.

9. Draw furry, round ears. Add curved lines inside the ears to define them.

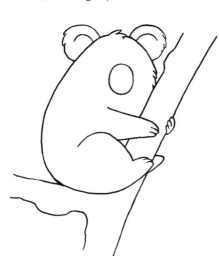

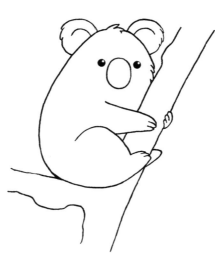

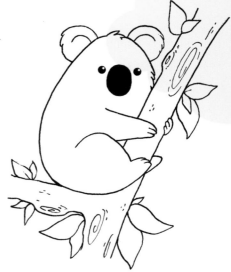

10. Draw a large oval nose in the middle of the face.

11. Draw 2 small circles for the eyes, then with a fine point pen, draw very small circles within those circles. Color the eyes in black, leaving the smaller circles white for "shining" eyes.

12. Color the nose in black. With a fine point pen, add details to the tree branches. Finish with some leaves.

Lovable Animals & Birds 77

Toucan

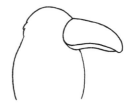

1. Draw a long beak.

2. Add a line to draw the lower part of the beak.

3. Draw the head, with tufts of feathers in the back, and part of the body with curved lines.

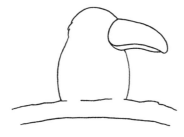

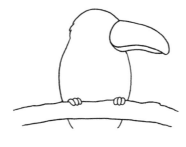

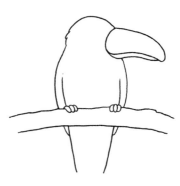

4. Draw a tree branch with 2 parallel lines that are slightly curving, leaving 2 openings where the feet will go.

5. Draw the feet in the open spaces on the top of the branch and continue drawing the body beneath the branch.

6. Extend lines for the tail from inside the lines you drew in step 5. Also add lines to the upper body, to define the wings.

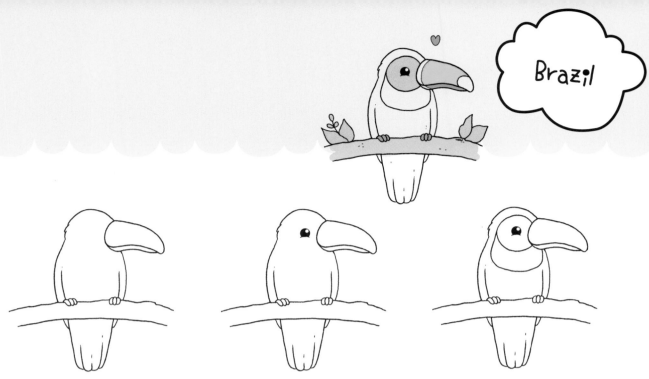

Brazil

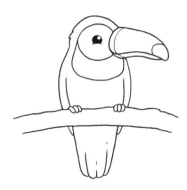

7. Complete the tail, adding lines to give the feathers texture.

8. Draw a small circle for the eye, then with a fine point pen, draw a very small circle within that circle. Color the eye in black, leaving the smaller circle white for a "shining" eye.

9. Draw a circle on the head, coming out of the beak and around the eye, then draw a wide U shape off the bottom of that circle to define the bird's breast.

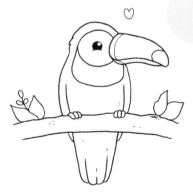

10. Add lines to the beak to give it that distinctive toucan look.

11. Add some leaves to the branch. With a fine point pen, add some dot and dash details to the feathers and branch for texture. I also added a heart as a doodle element!

Flamingo

1. Draw a line like the number 2, but with the tail end curving up.

2. Draw a line parallel to the one you drew in step 1, but make the tail end longer and extend it downward to start forming the bird's body.

3. Complete the flamingo's body with tufts of feathers on top and for the tail. Include 2 feathery knobs underneath the body for the legs to extend from.

4. Draw the tops of the skinny legs with parallel lines. End these lines with open nobs for the legs' joints.

5. Continue drawing the near leg so that the lower part bends.

6. Draw the far leg as a straight leg that falls behind the near leg. Don't forget to add some bird feet!

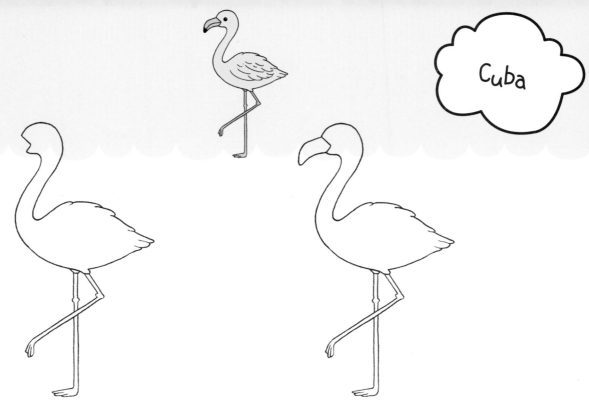

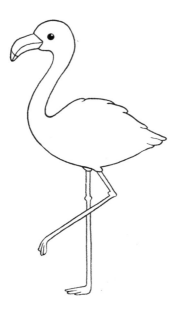

7. Close up the head with an inverted line that will fit the beak.

8. Draw a long, pointed beak off the line you drew in the previous step.

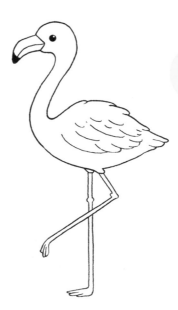

9. Draw a small circle for the eye, then with a fine point pen, draw a very small circle within that circle. Color the eye in black, leaving the smaller circle white for a "shining" eye. Also add lines to the beak to give it detail.

10. Color the tip of the beak in black. With a fine point pen, add curved lines on the body to define the feathers.

Lovable Animals & Birds 81

Get Inspired

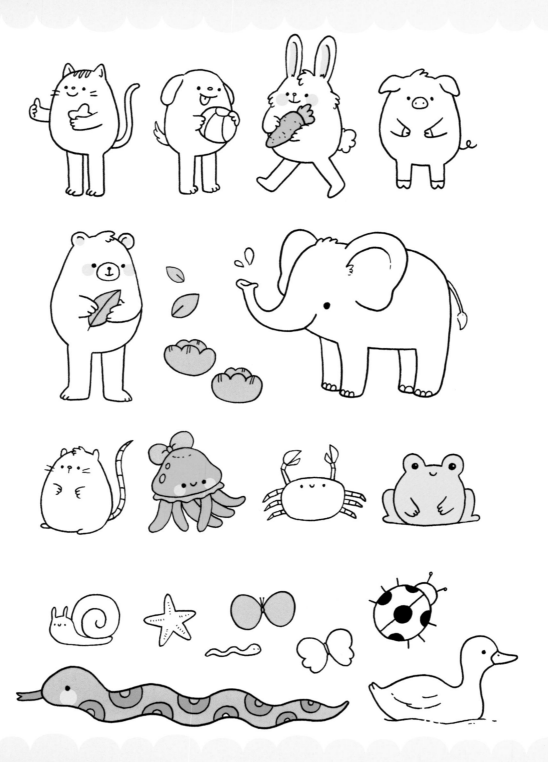

Here are some more of my kawaii animals and birds (and sea creatures and insects!) doodles to inspire you. Isn't it amazing that all of these creatures live with us on this planet?!

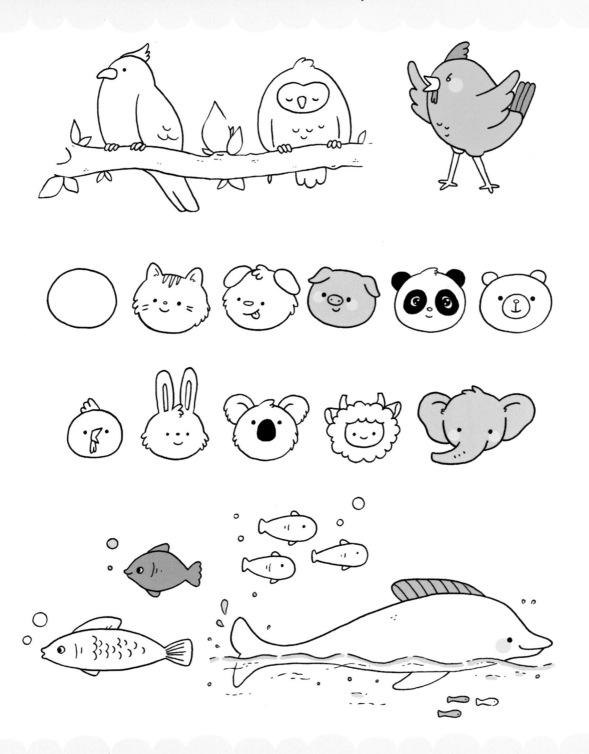

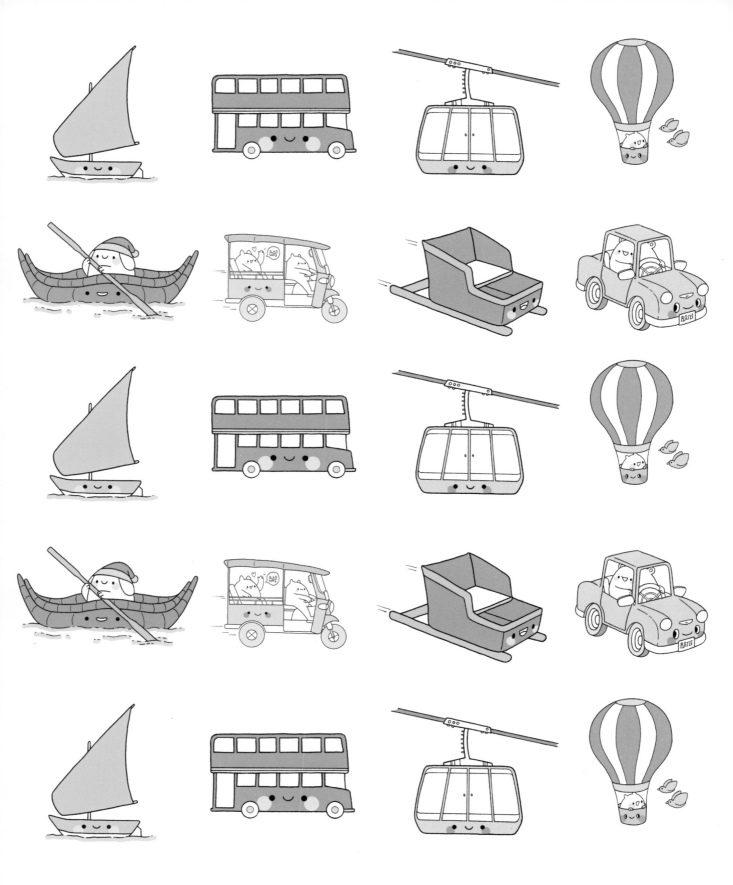

Charming Transportation

Felucca

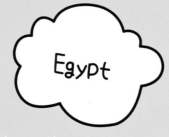 Egypt

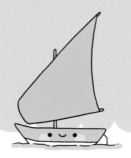

1. Draw 2 slanted lines at an angle from one another, with the top one longer than the bottom one.

2. Connect the lines to replicate a large boat sail blowing in the wind, then draw a small loop off the points at the top and bottom right.

3. Draw an incomplete boat shape below the sail.

4. From the center of the boat, draw a mast between the boat and the sail, then draw the top of the mast poking out from the sail.

5. Draw a series of wavy lines below the boat for water.

6. Draw a horizontal line near the bottom of the boat to define it and add the rudder off the back.

7. Draw a cute face, of course!

Hot-Air Balloon

1. Draw a shape that looks like the top of a light bulb.

2. Draw a 3-sided rectangle off the balloon, for the basket, making the sides slightly concave and the corners rounded.

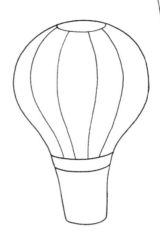

3. Draw a curved line at the top of the balloon, and then draw 4 curved vertical lines coming down from that line.

4. Draw a horizontal line across the center of the basket with a pair of cute hands on it.

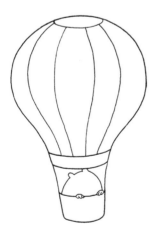

5. Draw a very round doodle monster with little ears to go with the hands.

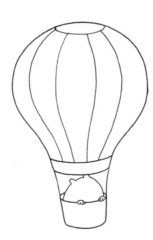

6. Add lines behind the doodle monster to define the back of the basket.

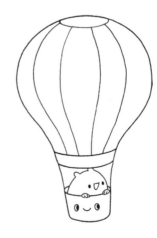

7. Draw a cute face on both the doodle monster and hot-air balloon, of course!

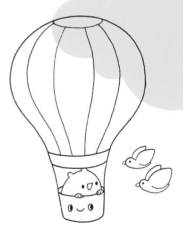

8. Add any additional elements to the scene! I drew some birds.

Charming Transportation 87

Gondola

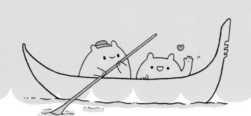

Italy

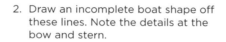

1. Draw 2 curved lines with a small opening between them and the right one curving up higher than the left one.

2. Draw an incomplete boat shape off these lines. Note the details at the bow and stern.

3. Draw a very round doodle monster with little ears, leaving a little opening on its right side. Make sure it is centered around the opening left between the curved lines drawn in step 1.

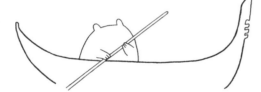

4. Give the doodle-monster gondelier little arms, with fingers. Make sure to position the arms so that they can hold an oar. Draw the oar so that it fills the open spaces left on the doodle monster and the gondola.

5. Draw a second doodle monster who is on vacation in Venice.

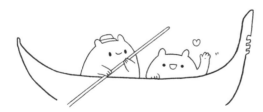

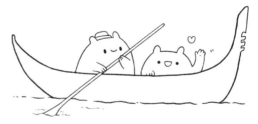

6. Draw a cute face on both doodle monsters, of course! I gave the gondelier a traditional hat and added doodle elements such as a heart and waving action lines.

7. Draw a series of wavy lines beneath the boat for the water and finish the oar. Use a fine point pen to draw thinner lines around where the oar enters the water.

Double-Decker Bus

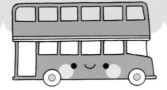

1. Draw a rectangle, making the top corners rounded.

2. Draw a bus shape off this rectangle, giving pointy edges to the front and back fenders.

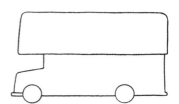

3. Add 2 wheels, then complete the bus shape. Add another line to the front fender to define it.

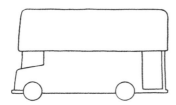

4. Add the windshield and a door in the back.

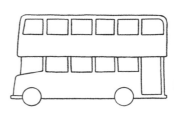

5. Add windows to both the top and bottom decks, making sure there are enough to fill the shape of the bus.

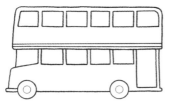

6. Add horizontal-line detailing to the upper deck and circles within the wheels.

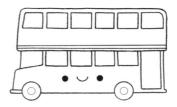

7. Draw a cute face, of course!

Toboggan

1. Draw an L shape with a rounded point and the bottom line longer than normal.

2. Draw a line, kind of like a step, for the side of the toboggan, then draw another line for the back.

3. Draw a line like you did in the previous step that runs parallel to it, for the sled's right side. Also draw lines to close up the sled.

4. Add line details to the inside of the toboggan, for the seat and floor.

5. Add the toboggan's rails, making the edges rounded. With a fine point pen, draw some action lines off the back of the toboggan. Whee!

6. Draw a cute face, of course!

Wings of Tatev

1. Draw a 3-sided trapezoid, making rounded corners.

2. Close up the trapezoid, noting how the bottom corners curve in.

3. Draw parallel lines three-quarters of the way down the center of the trapezoid. Off the top of these lines, add 4 horizontal lines of equal length.

4. Draw a pair of parallel lines, coming down from the openings in the horizontal lines from the previous step, making sure they slant toward the sides of the tram. Draw lines at the bottom of these segments to define the 4 windows.

5. Draw horizontal lines within and across your tram windows, connecting them to the lines on the sides. Add doorknobs.

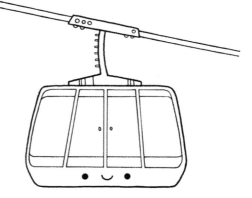

6. Draw the contraption on top of the tram that connects the tram to the cable; it looks kind of like an outlined I shape. Also add some cable line.

7. With a fine line, add details to that contraption. Make sure to look closely at my drawing. And draw a cute face, of course!

Tuk Tuk

Though I get detailed in this doodle, feel free to make your Tuk Tuk as simple or detailed as you want. Look closely at my drawings to capture all the details!

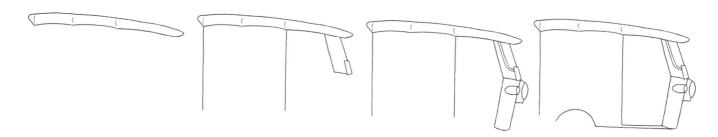

1. Draw the canopy of the tuk tuk so that it is narrower at the front and slants down.

2. Draw 2 vertical lines for the side of the vehicle and a windshield off the front of the canopy.

3. Add a headlight and hood to the tuk tuk. Also add more detail to the windshield. Make sure to look closely at my drawing.

4. Draw part of the bottom of the vehicle with a wheel well.

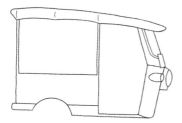
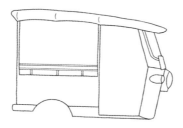
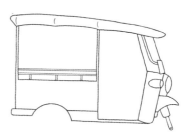

5. Draw more lines to close up the bottom and give it some heft. Also draw a 3-sided rectangle to define the side more.

6. Add rails to the side with narrow vertical and horizontal parallel lines.

7. Off the hood, draw a fender for the front wheel and the parts that connect it to the tuk tuk.

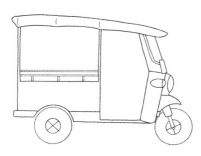

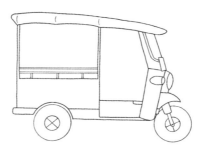

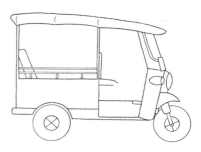

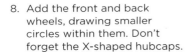

8. Add the front and back wheels, drawing smaller circles within them. Don't forget the X-shaped hubcaps.

9. Add lines inside the front of the tuk tuk to define the floor.

10. Draw the front and back seats.

11. Add some doodle monsters! Make sure the driver is positioned correctly to do his job.

12. Add more details to the front, where the driver is sitting (look closely at my drawing), along with a steering wheel. Give the doodle monsters cute faces and add some more doodle elements. I drew a heart, a word bubble, and some waving action lines.

13. Draw a cute face on the tuk tuk, of course!

Charming Transportation 93

Totora Boat

1. Draw 2 curved lines next to each other that don't connect.

2. Draw the bow and stern, giving them rounded points.

3. Add shorter parallel lines to give the boat some heft.

4. Add a series of wavy dashes underneath the boat for water.

5. Draw the left side of a round doodle monster, leaving an opening for an oar, making sure to position the doodle monster around the opening in the boat. Add some fun headgear.

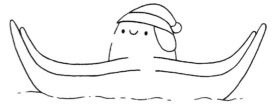

6. Complete the right side of the doodle monster and draw a cute face, of course!

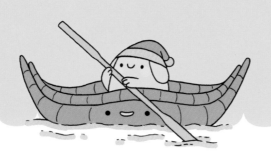

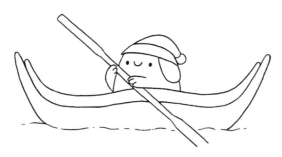

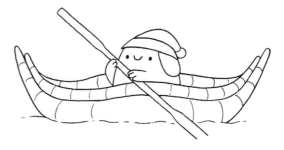

7. Draw an oar so that it fills the openings of the doodle monster and boat. Give your doodle monster cute hands, with fingers, to hold the oar.

8. With a fine point pen, add lines all over the boat to give it texture.

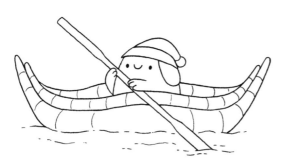

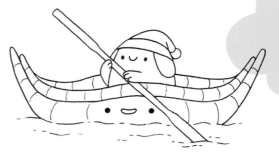

9. Continuing with the fine point pen, add more series of wavy dashes to the water. Also draw lines around where the oar enters the water.

10. Draw a cute face on the boat, of course!

Vintage Car

Though I get detailed in this doodle, feel free to make your Vintage Car as simple or detailed as you want. Look closely at my drawings to capture all the details!

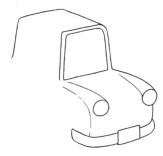

1. Draw an L shape at an angle.

2. Draw a vertical line off the back line of the L shape and a 3-sided trapezoid off the front line. Draw a smaller, complete trapezoid within the 3-sided one.

3. Draw 2 curved lines to define the shape of the hood, ending them in circles, for the headlights.

4. Add more curving lines to the hood to define it. Draw a rectangle at the bottom center of the hood for the license plate. Draw the front fender off the sides of the license plate with curving parallel lines that connect with rounded edges.

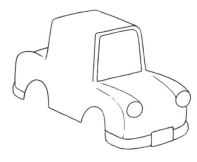

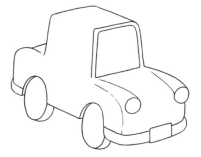

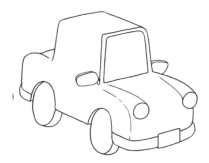

5. Draw the bottom side of the car with 2 wheel wells, then draw the back of the car and part of that fender. Make sure to look closely at my drawing.

6. Draw circles for the wheels, then outline them to show their width.

7. Draw the 2 side-view mirrors, making sure to outline their tops.

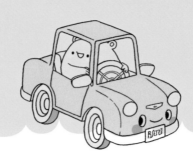

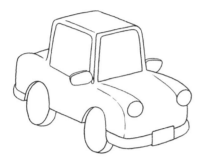

8. Draw a trapezoid on the side, like the one you drew in step 2, for a side window. Add a line on top of the car for definition.

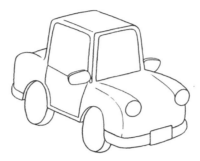

9. Add a door to the side of the car that hugs the back wheel well.

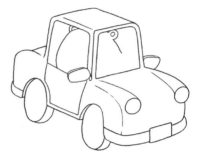

10. Start drawing the body of a very round doodle monster, leaving an opening on the right side for the steering wheel.

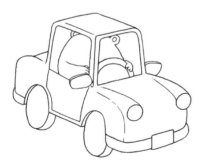

11. Draw a semicircle with parallel lines for the top of the steering wheel. Give the doodle monster cute arms and hands, with fingers, so that they are on the steering wheel.

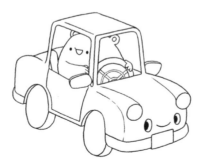

12. Add details to the steering wheel and give the doodle monster and the car cute faces, of course!

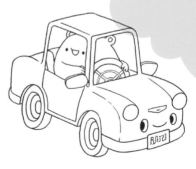

13. Add an emblem to the car's hood and text to the license plate to make it a vanity plate.

Get Inspired

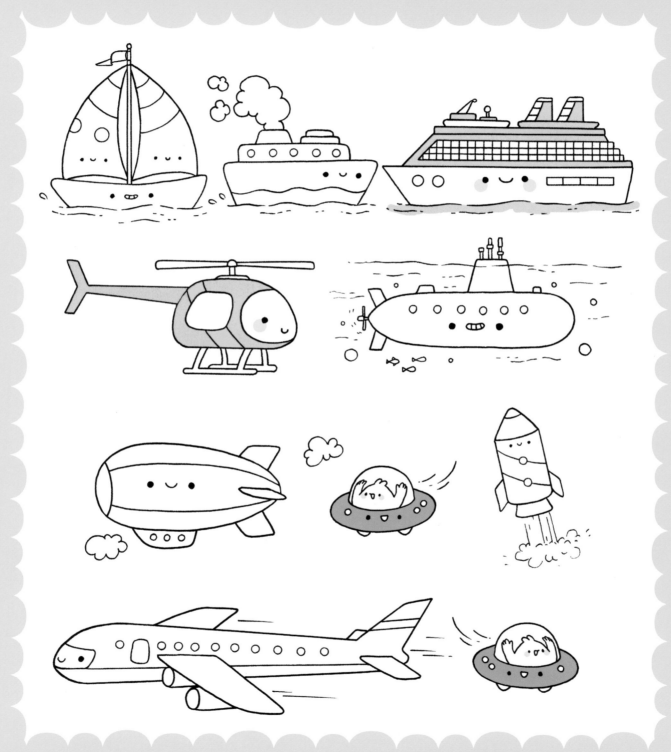

Kawaii Doodle Cuties

Here are some more of my kawaii transportation doodles to inspire you. By land, sea, or air, there are so many different ways to get around!

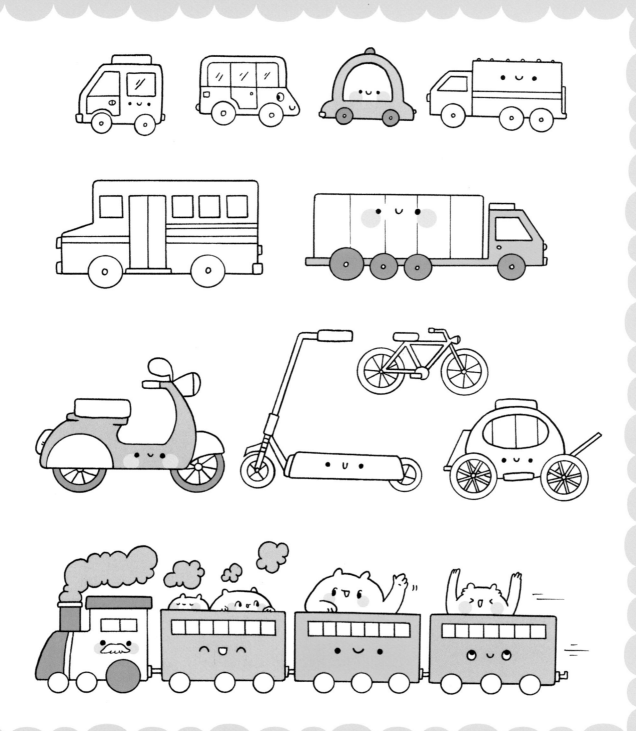

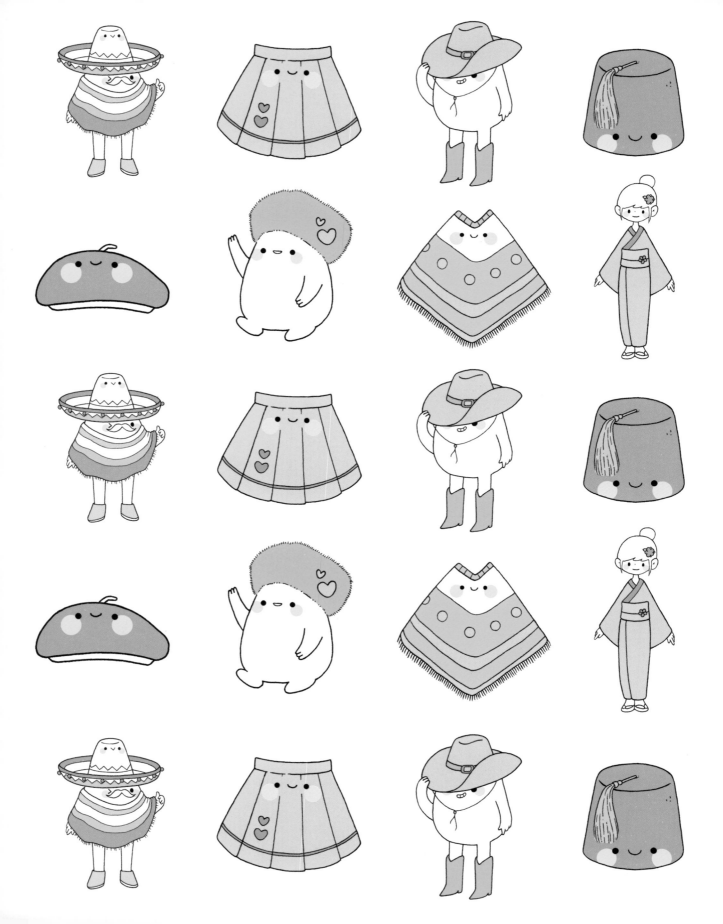

Fetching
Fashion

Beret

France

1. Draw a bean shape.

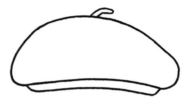

2. Draw a narrow 3-sided rectangle off the bottom of the bean, making the corners rounded. Add a "stem" on top.

3. Draw a cute face, of course!

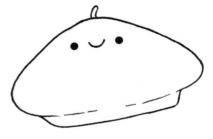

Here's another beret style you can draw!

Fez

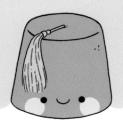

1. Draw an upside-down U shape.

2. Connect the sides, making rounded corners.

3. Draw curved lines at the top of the hat, leaving an opening between the lines.

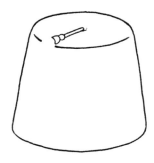

4. Draw the fastening of the tassel from the top center of the hat, pointing in the direction of the opening. Look closely at my drawing to see the detail.

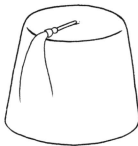

5. Draw 2 lines coming down from the fastener for the outline of the tassel.

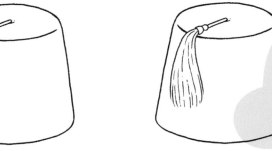

6. With a fine point pen, draw vertical lines of varying lengths to define the tassel and give it textue.

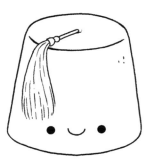

7. Continuing with the fine point pen, draw a group of dots on the fez to give it texture. Draw a cute face, of course!

Poncho

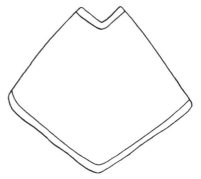

South America

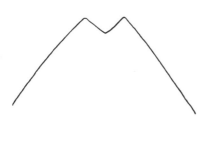

1. Draw a mountain shape.

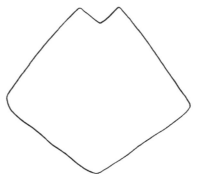

2. Connect the sides with a wide V shape, making rounded corners.

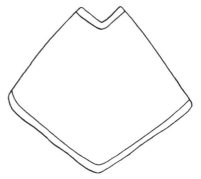

3. Outline the neck and bottom of the poncho with lines running parallel to the shapes.

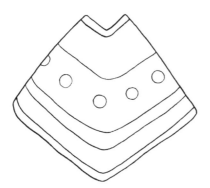

4. Decorate the poncho! I drew stripes and circles.

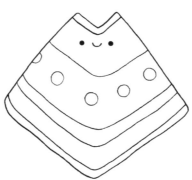

5. Draw a cute face, of course!

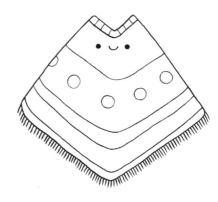

6. With a fine point pen, decorate the neckline and add fringe to the bottom.

K-pop Skirt

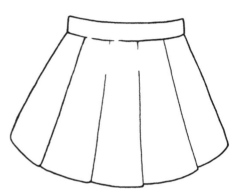

1. Draw a rectangle, making the longer lines curved.

2. Draw a skirt panel with the bottom right being a little longer and making rounded corners.

3. Continue drawing 4 more skirt panels. The bottom of the center panel should be straight across and the 2 panels on the right should be longer on their bottom-left sides. Leave some open space in the center panels for a face.

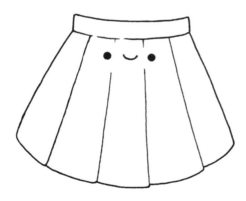

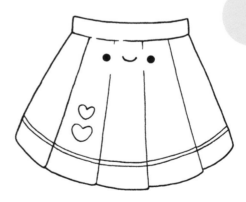

4. Draw a cute face, of course!

5. Embellish your K-pop skirt! I added a stripe and hearts.

Ushanka

Russia

1. Using a pencil, draw an outline of the hat, which is somewhat tall.

2. With a fine point pen, draw a curved series of dots and dashes where the hat would sit on the head. Continuing with the fine point pen, draw short vertical lines along the pencil guideline to replicate fur. Erase the pencil guideline.

3. Draw a very round doodle monster from the base of the hat. Don't forget the feet!

4. Draw the arms and hands, with fingers, in proportion to the body.

5. Embellish the hat (I added hearts) and draw a cute face, of course!

Cowboy Hat

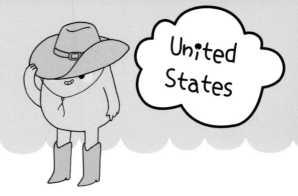

 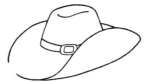

1. Draw a shape like an incomplete potato chip.

2. Off the right curve, draw a loop.

3. Draw a broad upside-down U shape for the crown.

4. Draw an S-shaped line at the top of the crown for an indent. Also add a buckle detail to the hat.

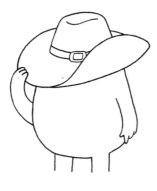 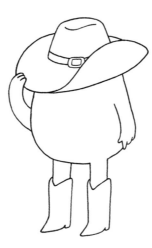 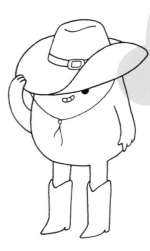

5. Draw a doodle monster who is tipping the hat. Note how its hand fills the opening on the brim.

6. Don't forget a pair of cowboy boots!

7. Draw a stampede string for the hat and a cute face, of course!

Non La

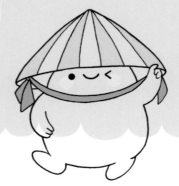

 Vietnam

1. Draw a wide upside-down V shape.

2. Connect the sides with a curved line, leaving a small opening in the line on the right side. Add small curved lines off the hat's sides.

3. Where you left the opening in step 2, draw fingers as if they are holding on to the hat. Add a pair of oblong triangles to the left side of the hat.

4. From the oblong triangles, draw a curving ribbon using parallel lines. In the space between the ribbon and hat, draw the outline of a doodle monster's head.

5. Draw the rest of the doodle monster's body below the ribbon.

6. Add vertical lines to the hat and draw a cute face, of course!

Sombrero & Serape

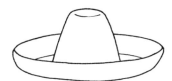

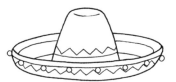

1. Draw an incomplete oval, then add a curved line for the brim.

2. Draw a tall upside-down U shape for the crown, then add curved lines at the top of the crown and inside the brim to define the hat's shape.

3. Decorate your hat! I drew pom-pom trim and a combination of zigzags and straight lines.

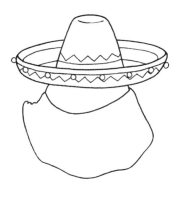

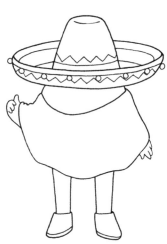

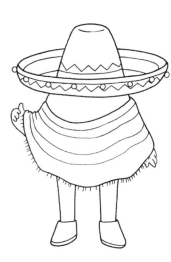

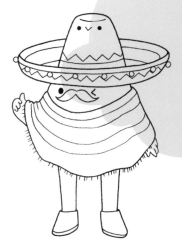

4. From the bottom of the hat, draw a doodle monster's head and a serape shape, which is like a blanket or shawl draped over a body.

5. Draw the rest of the doodle monster's body. Don't forget the shoes!

6. Decorate your serape! I drew stripes and fringe with a fine point pen.

7. Draw a cute face on both the sombrero and the doodle monster, of course!

Kimono

1. Start the face by only drawing the ears. Make sure that they are far enough apart to fit the face.

2. Connect the ears with a wide V shape for the lower face and chin. Draw a semicircle off the tops of the ears for the head. Add a hairstyle! I drew a bun, bangs, and wisps of hair in front of the ears.

3. Embellish the hair with a beautiful flower, if you like. Also give the ears a little detail to define them. And draw a cute face, of course!

4. Draw a narrow neck with 2 short, concave lines.

5. To begin the fold of the kimono, draw a short, slanted line off the left side of the neck, then draw a longer, slanted line off the right side that touches the first line.

6. Begin the flowing sleeves with lines that extend out and down from the shoulders.

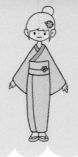

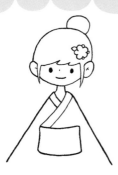

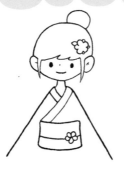

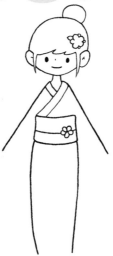

7. Add parallel lines to the ones you drew in step 5 to thicken the neckline. Also draw a rectangle with slightly curving lines for the obi.

8. Decorate the obi! I drew a horizontal line and a flower.

9. Extend the kimono from the bottom of the obi. A kimono is very narrow, so make the lines slightly curved in.

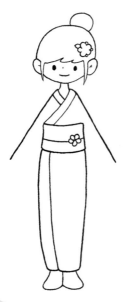

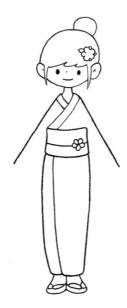

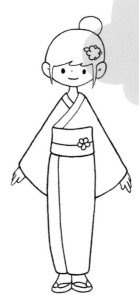

10. Draw a vertical line down the bottom of the kimono, for the fold. Don't forget to add the feet! They are covered in socks, so you don't need to draw toes.

11. Add the traditional wooden sandals called *geta*.

12. Complete the flowing sleeves with hands peeking out.

Get Inspired

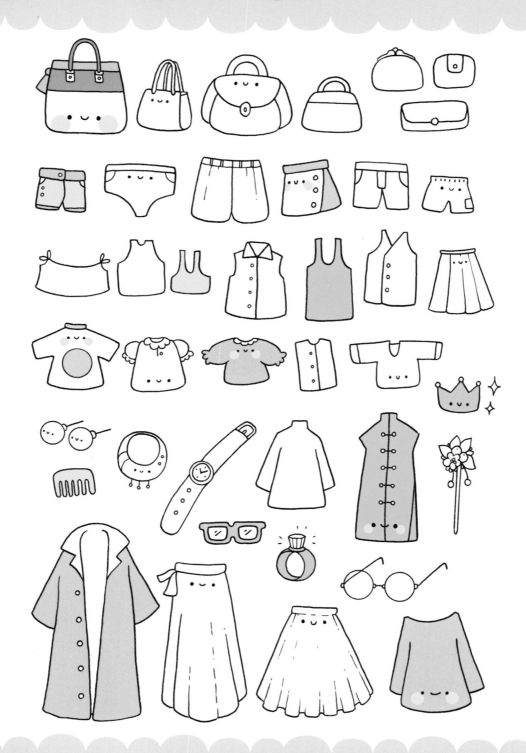

Here are some more of my kawaii fashion doodles to inspire you. Whether it's a traditional costume or a fashion trend, it's fun to see what people wear across the globe!

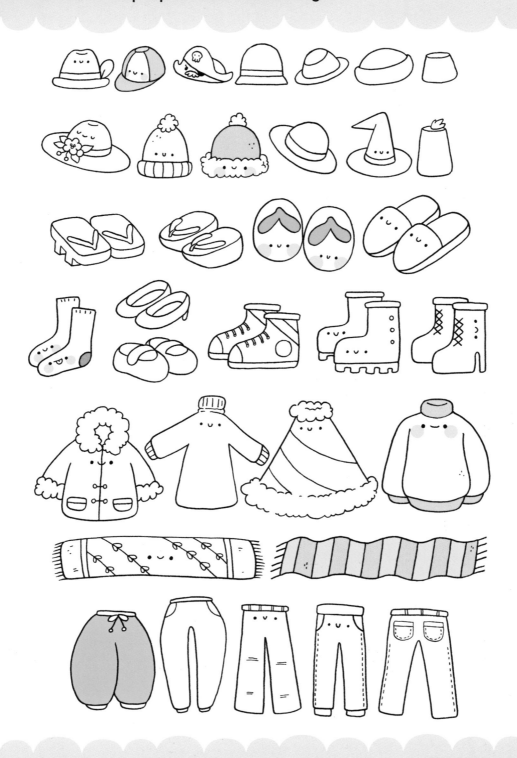

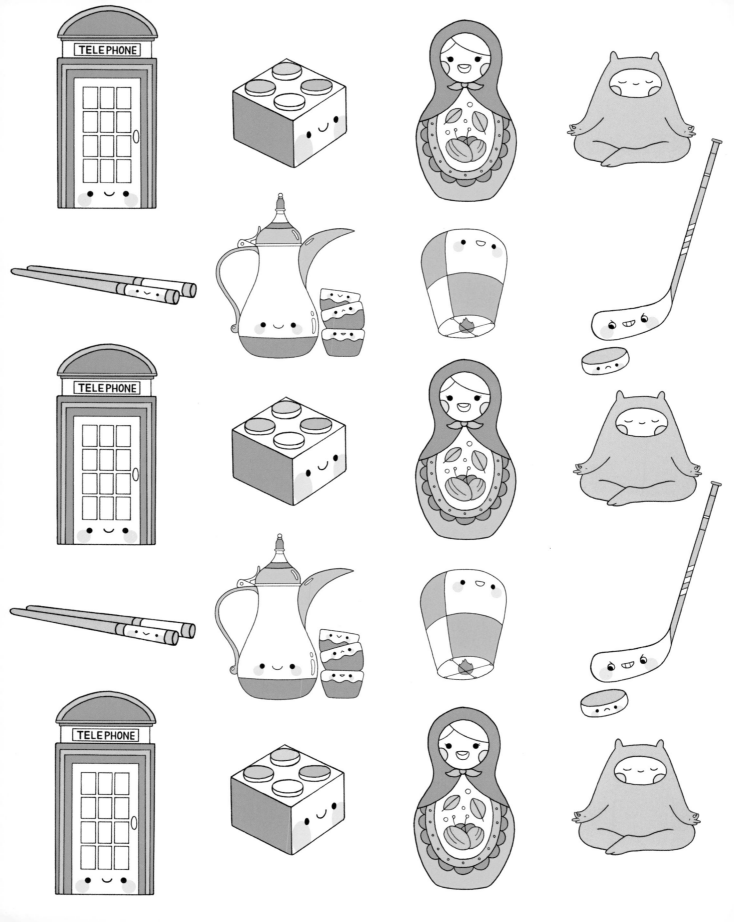

Everyday
Cute

Chopsticks

1. Draw 2 lines that start out parallel and then diverge.

2. Connect them with a circle on the wider end and a rounded point on the narrower end.

3. Embellish with stripes.

4. Draw a cute face, of course!

5. Don't forget to make it a pair!

Hockey Stick & Puck

Canada

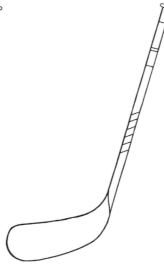

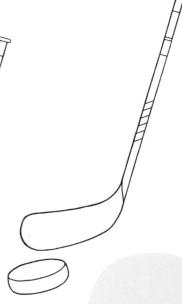

1. Draw long parallel lines at an angle.

2. Connect the lines at the top with a small, squat oval. For the heel and toe of the stick, draw a shape like the foot of a sock. Makes sense, right?

3. Decorate the stick with stripes or any design you like.

4. Make the puck by first drawing a circle at an angle and then adding a curved line to the bottom of the circle.

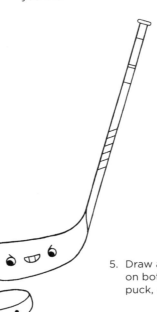

5. Draw a cute (or sad) face on both the stick and puck, of course!

Telephone Box

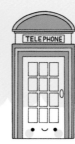

England

1. Draw a rectangle.

2. Draw three 3-sided rectangles within this rectangle and a fourth one on top.

3. Add molding to the top box by drawing very narrow rectangles.

4. Off this molding, draw parallel lines that arch like a rainbow.

5. Add a rectangle with the word "telephone" neatly written inside it in all caps.

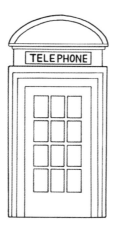

6. Draw small windows in the door of the telephone box.

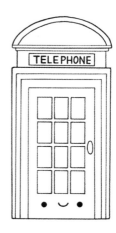

7. Finish with a doorknob and a cute face, of course!

Yoga

India

1. Draw a wide doodle monster head with cute ears on top.

2. Draw the arms of the doodle monster in proportion to its body. Add the fingers so that they are in the *gyan mudra* position.

3. The doodle monster is going to be sitting cross-legged, so draw the first leg in a bent position off the right side, in proportion to its body. Draw the other leg to look as if the bottom part is tucked behind or under the first leg.

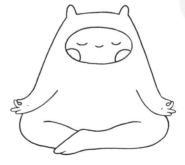

4. Draw an oval within the head.

5. Draw a cute face, of course! With a fine point pen, define the palms of the hands.

Lego Bricks

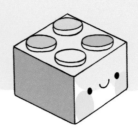

Option 1

1. Draw a rectangle.

2. Add 4 small 3-sided rectangles on top.

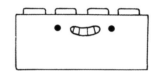

3. Draw a cute face, of course!

Option 2

1. Draw a cube.

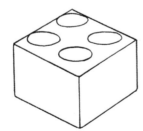

2. Draw 4 small circles on top of the cube.

3. Add curved lines to the 4 small circles to give them depth.

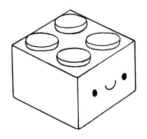

4. Draw a cute face, of course!

Floating Lantern

China

1. Draw a broad upside-down U shape with the sides slanting in.

2. Connect the sides with an oval.

3. Draw an X shape in the oval, with tiny semicircles where the lines meet the paper lantern. Add a flame—the heat makes the lantern float!

4. Draw a vertical and a horizontal line on the "paper" for the lantern's wire frame.

5. Draw a cute face, of course!

Dallah

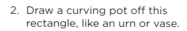

1. Draw a very narrow rectangle with rounded edges.

2. Draw a curving pot off this rectangle, like an urn or vase.

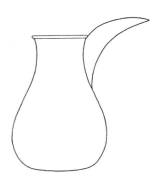

3. Draw a shape like a crescent moon off the right side of the pot.

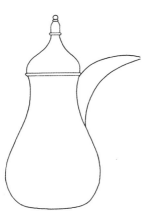

4. Add a lid. Make sure to look closely at my drawing to get the details.

5. Draw a curving handle.

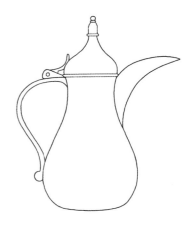

6. Add a clip to the back of the lid. Again, look closely at my drawing to get the details.

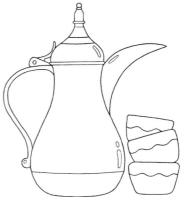

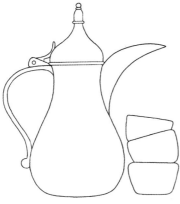

7. Draw a set of stacked cups using full and partial upside-down trapezoid shapes, making the corners rounded.

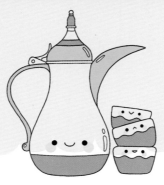

8. With a fine point pen, draw small oblong shapes on the pot to give it some shine. Decorate your cups! I drew wavy horizontal lines.

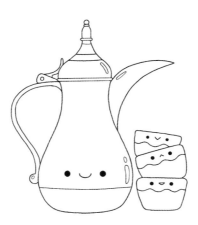

9. Draw cute faces, of course!

Matryoshka Doll

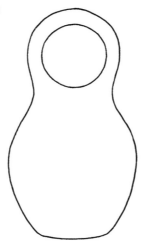

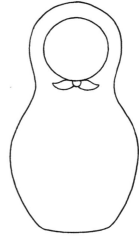

1. Draw a shape, kind of like a squatter version of a bowling pin.

2. Draw a circle in the upper part of the shape, for the face.

3. Add a cute knotted tie, like a scarf knotted under a chin.

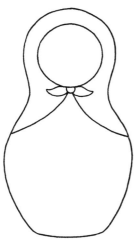

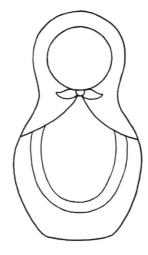

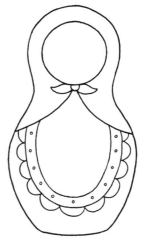

4. Draw 2 lines curving off the knotted tie to the sides of the doll, for the shawl.

5. Draw parallel U shapes in the lower part of the body.

6. With a fine point pen, add some decorative elements. You can do whatever you want, but I kept my decorations more traditional in a folk-art style, with small circles and scallops.

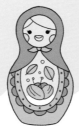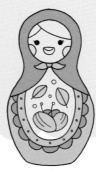

Russia

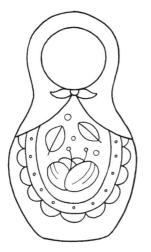

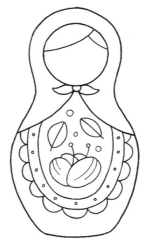

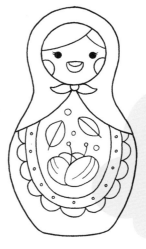

7. Keep decorating the body of your doll.

8. Draw in some curved lines for hair.

9. Draw a cute face, of course!

Get Inspired

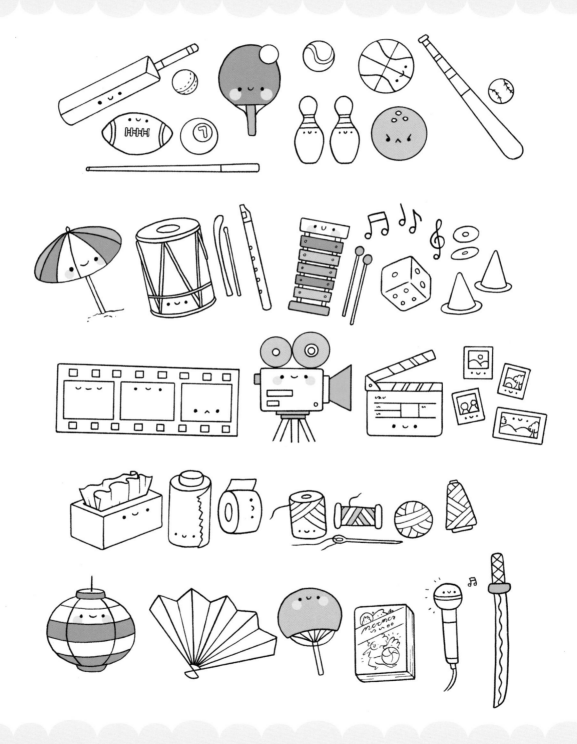

Here are some more of my kawaii everyday object doodles to inspire you. Check out all the different things we use daily around the world!

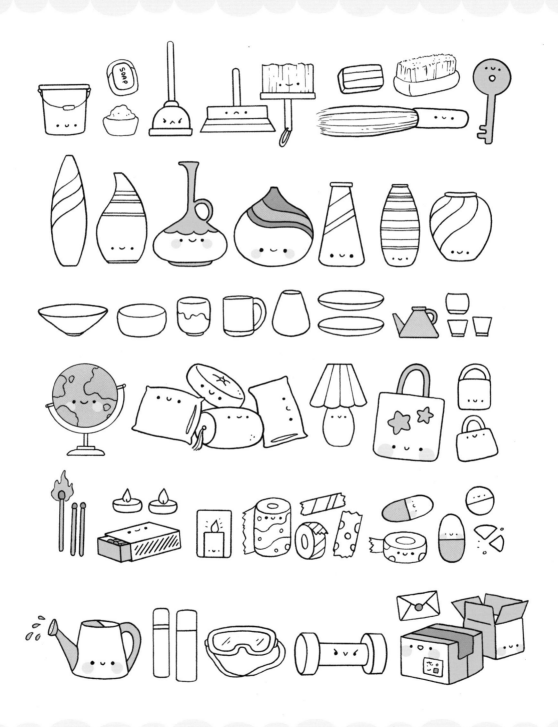

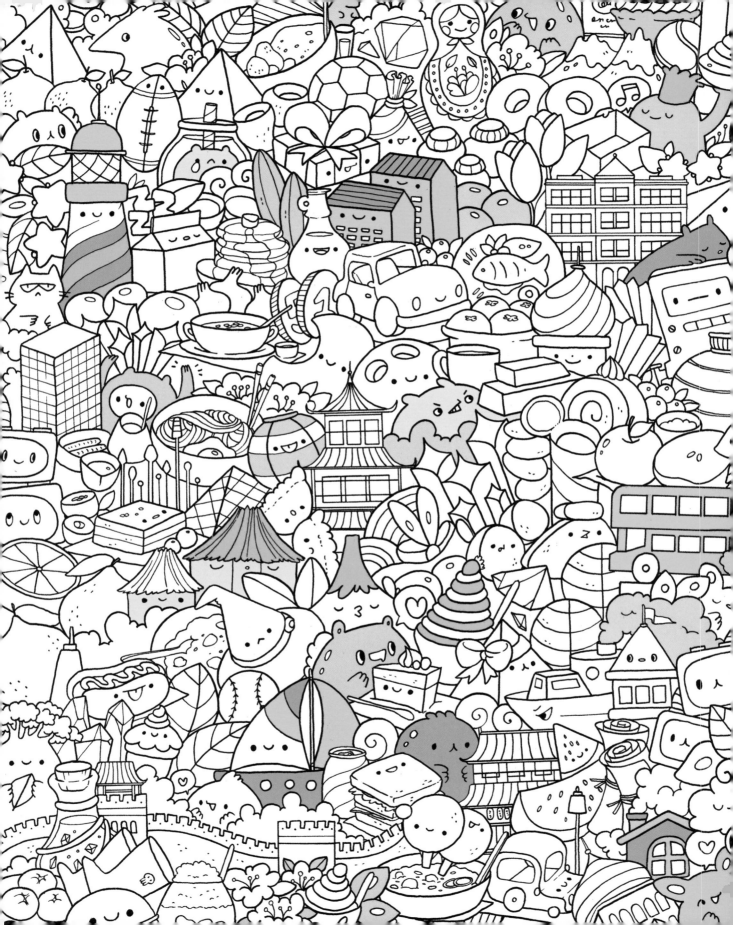

Fun Time!

The pages in this section are double the fun!
They are Search-&-Find Puzzles
that you can also use as Coloring Pages.

Each of the following 6 puzzle scenes
(2 pages per puzzle) has a highlighted item
that you need to search and find.
The answers start on page 142.

Don't cheat!

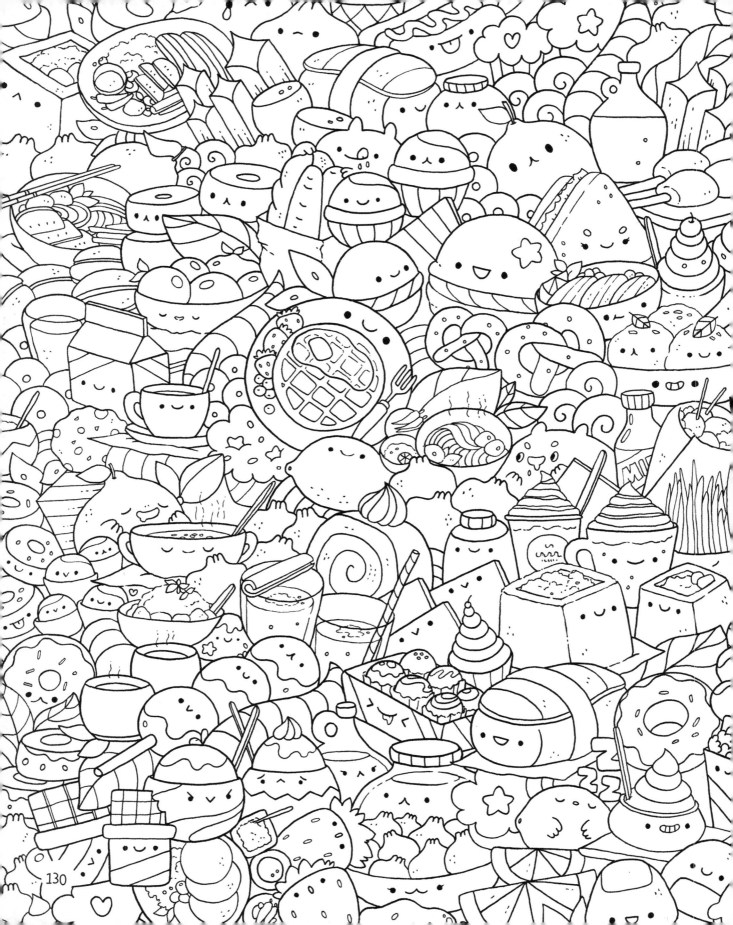

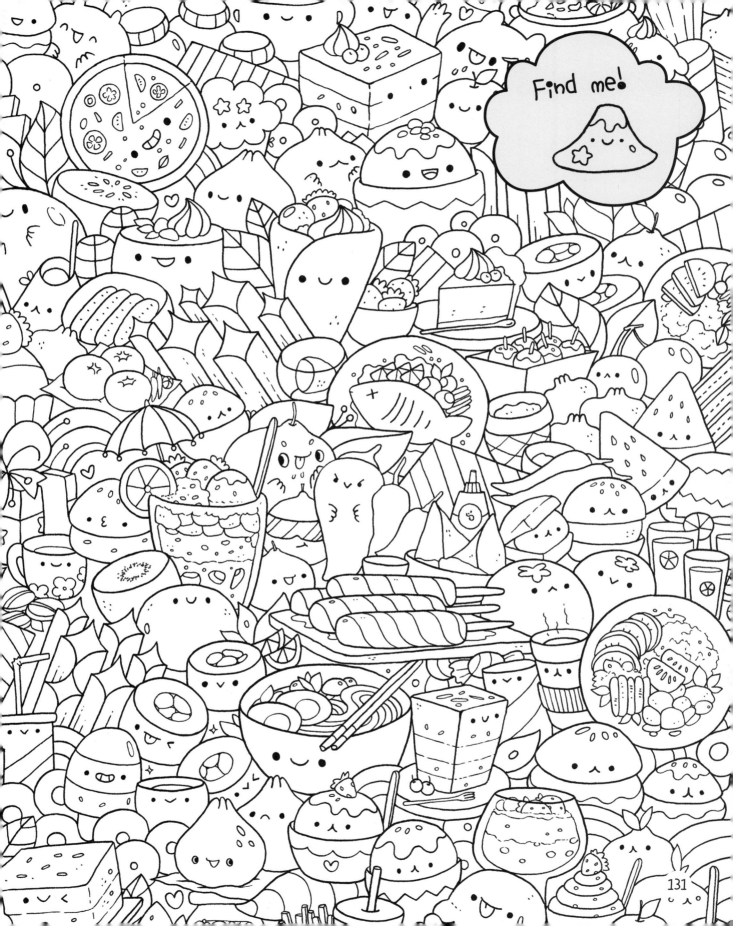

Find me!

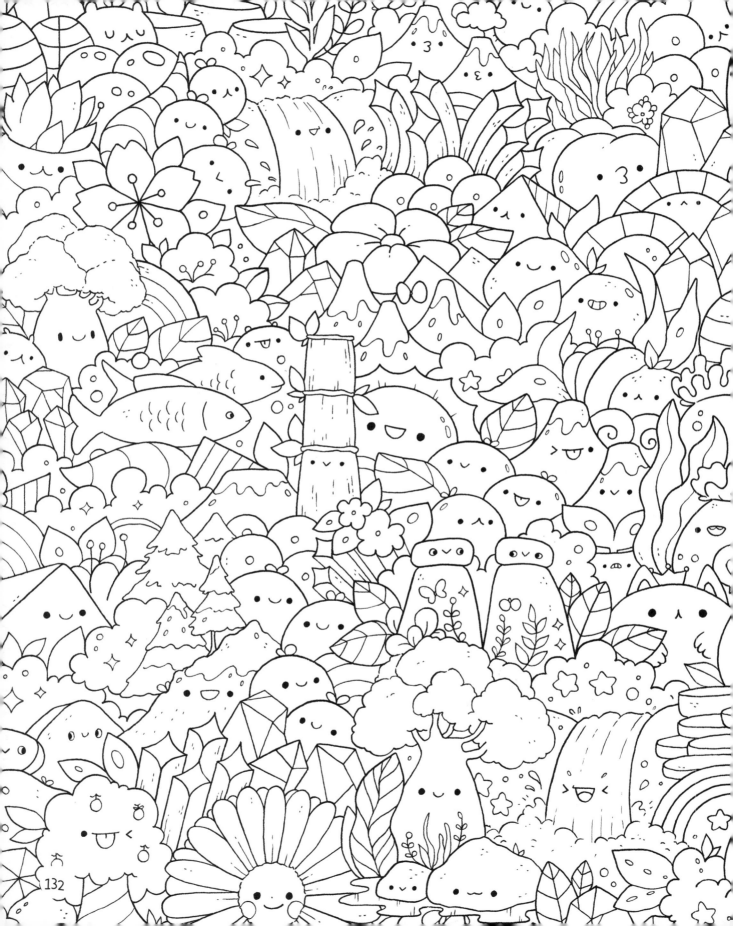

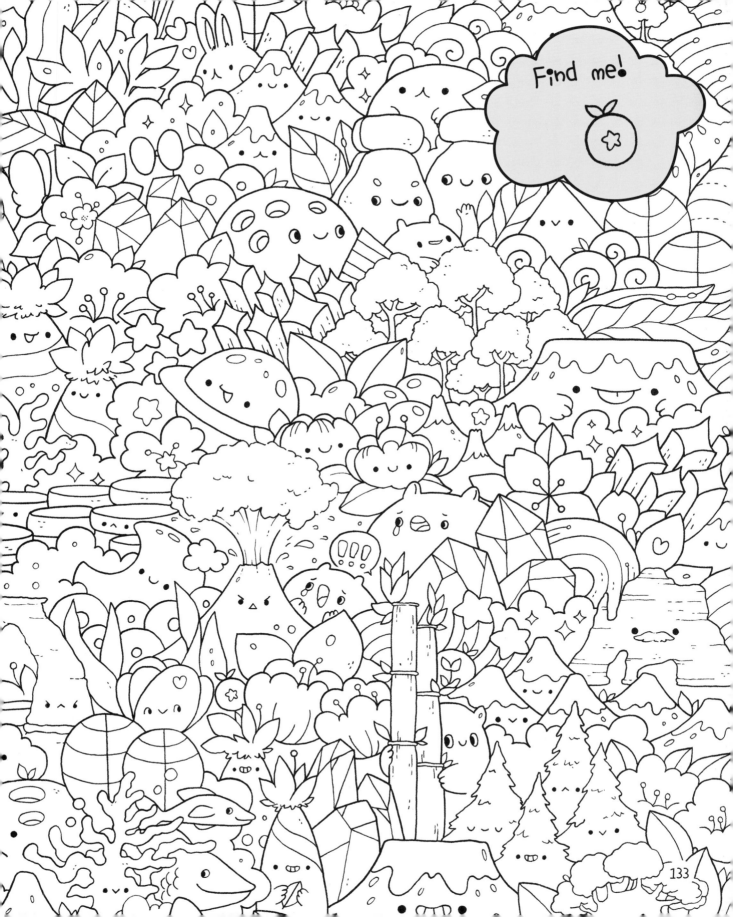

Find me!

133

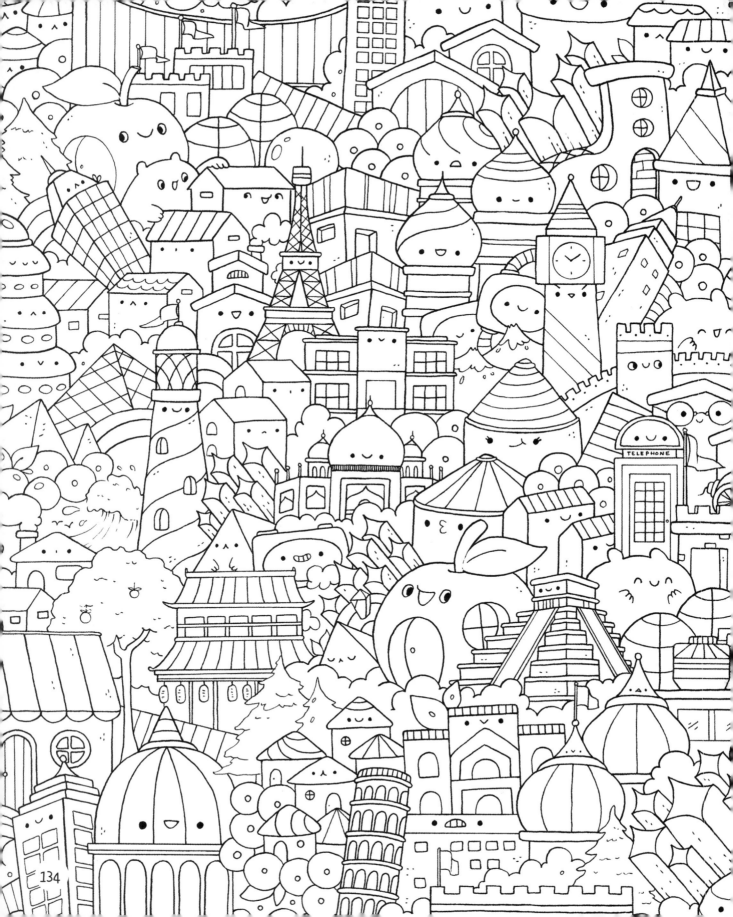

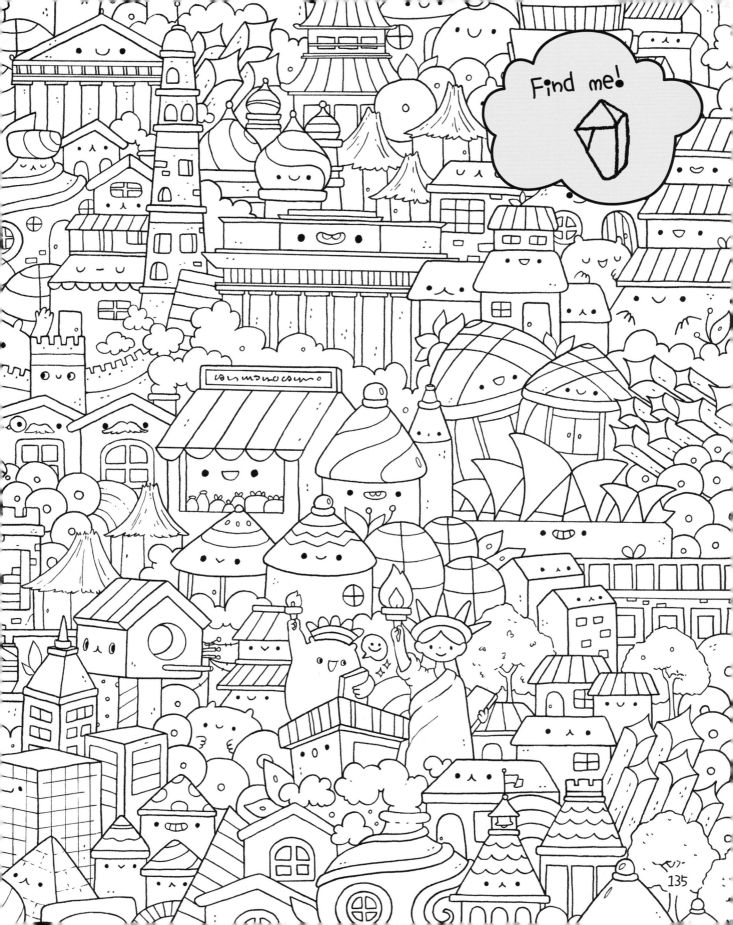

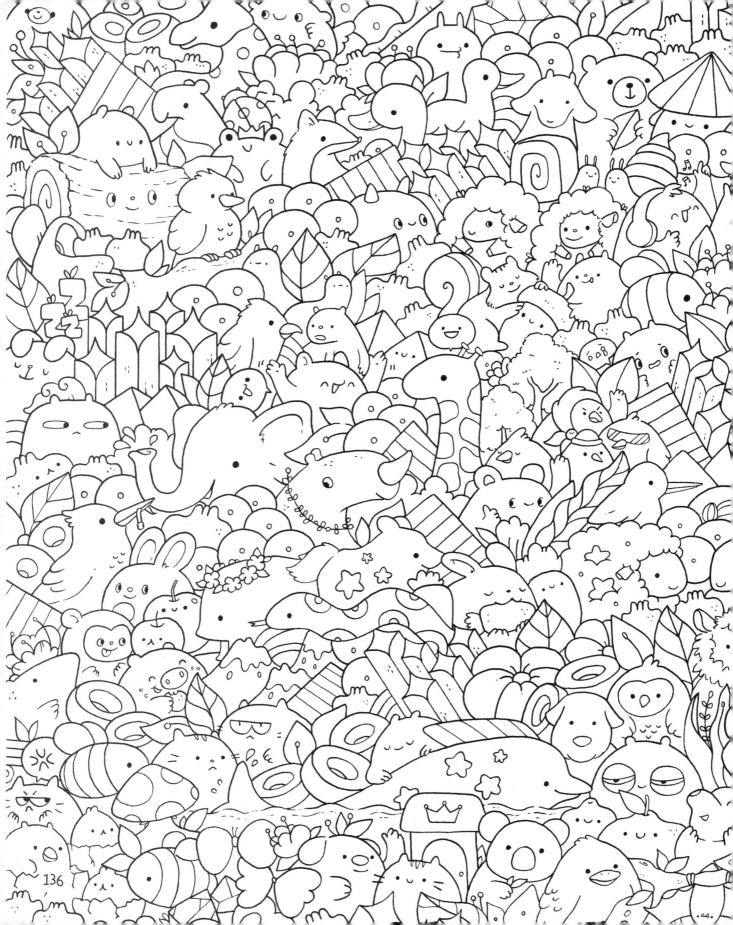

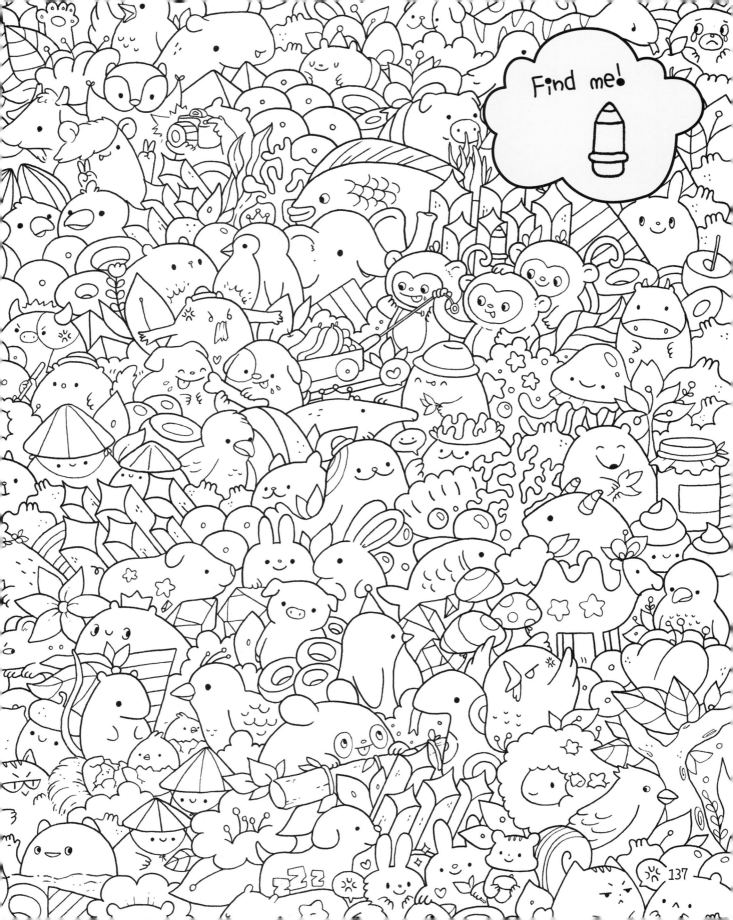

Find me!

137

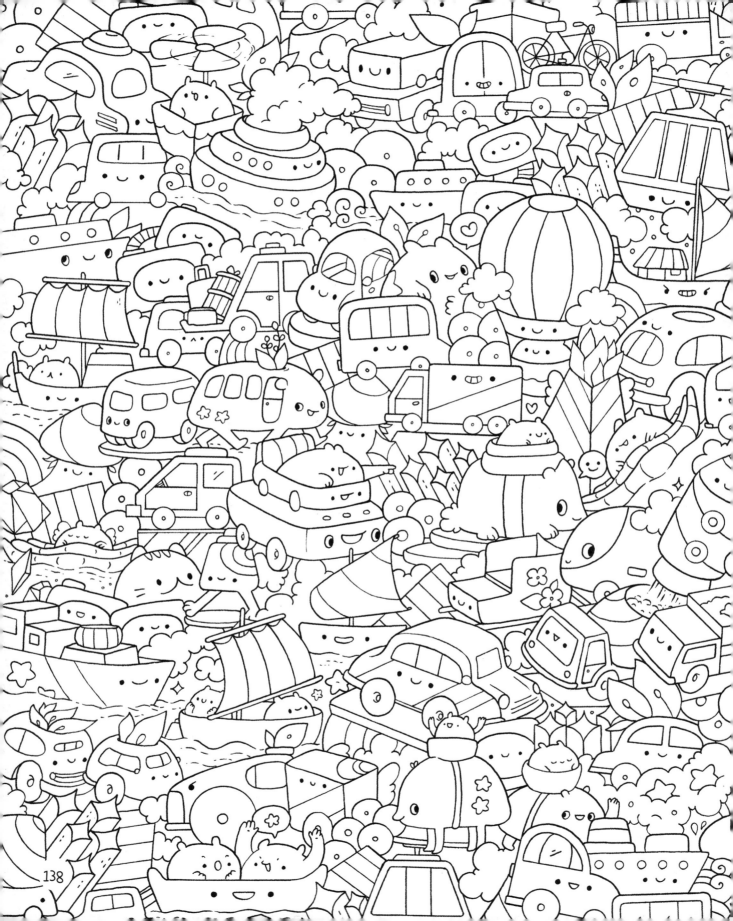

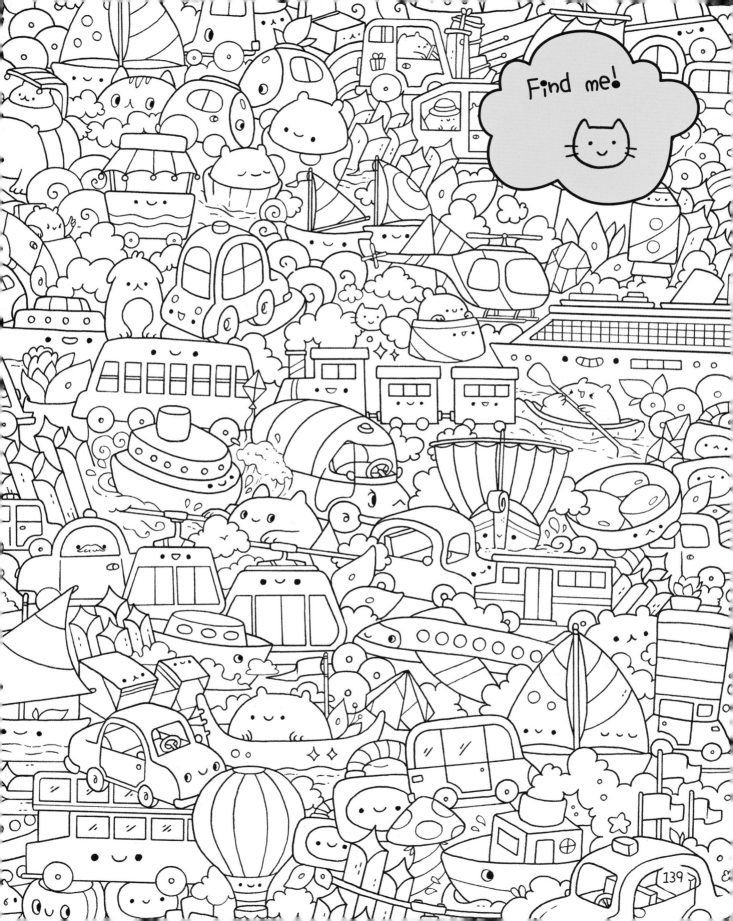

Find me!

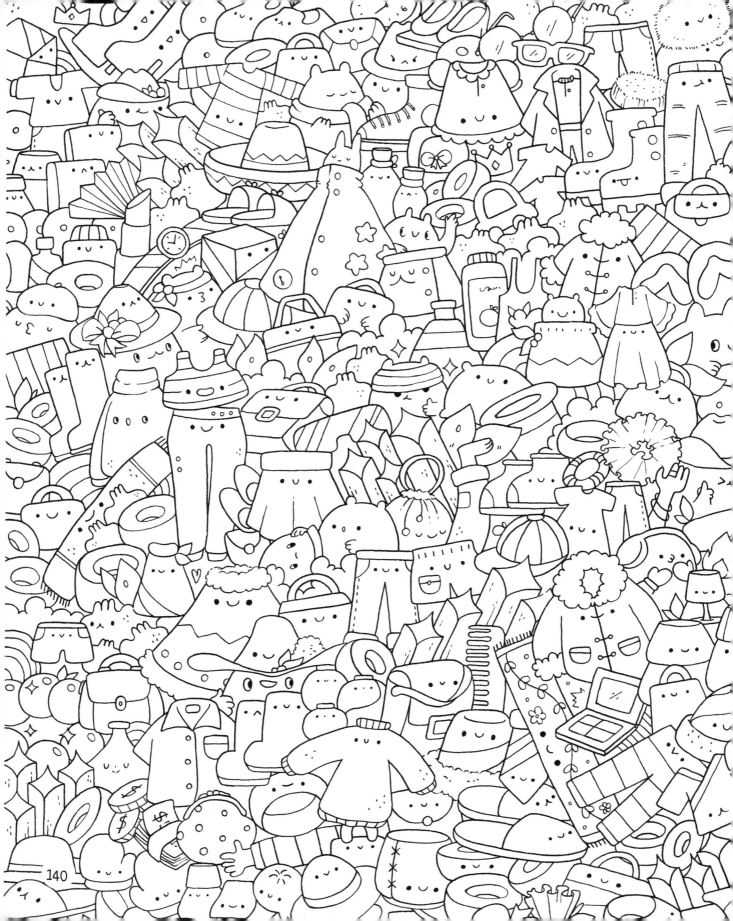

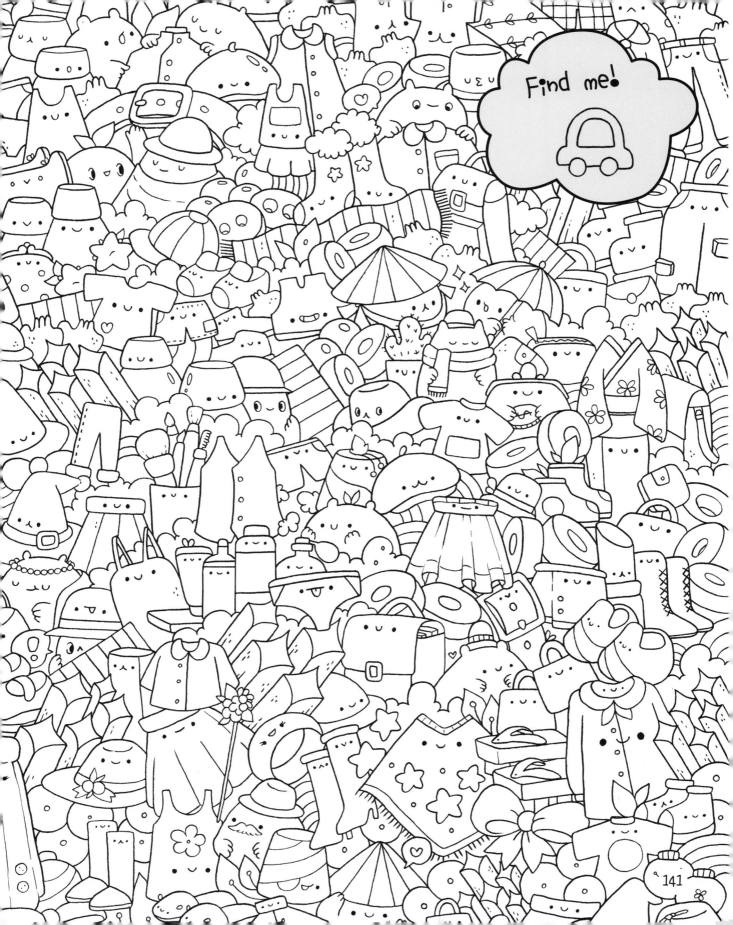

Find me!

141

Search-&-Find Puzzle Answers!

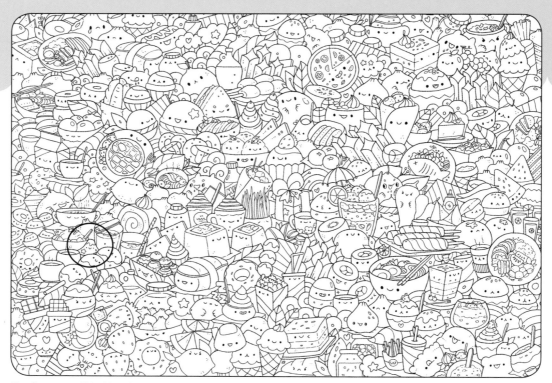

Key for pages 130–131

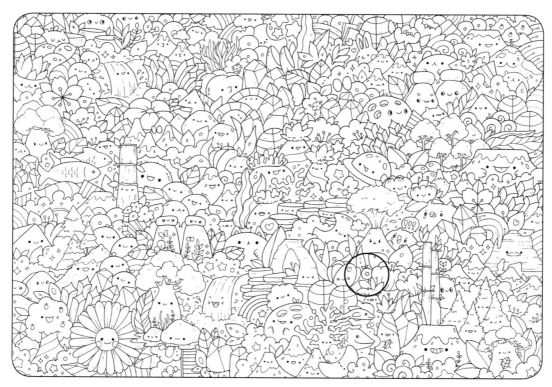

Key for pages 132–133